Painting with
Brenda Harris

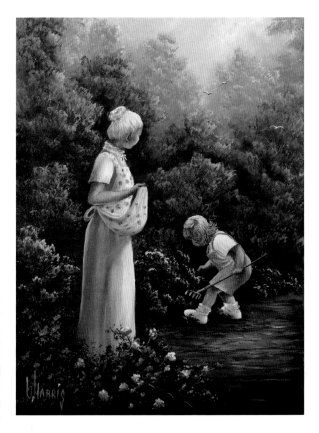

VOLUME 4:
GORGEOUS GARDENS

DISCARDED
Richmond Public Library

NORTH LIGHT BOOKS
CINCINNATI, OHIO
www.artistsnetwork.com

Brenda Harris started painting as a hobby at the age of thirty-one. A few years later, encouraged by her family and friends, Brenda entered her first juried art show. Her style and ability proved to be a winning combination as she was awarded high honors in the show. Brenda continued to exhibit in shows throughout the country and to win numerous awards. Yet, it was not until she started sharing her techniques with others that her true talent emerged—teaching.

Since 1986, Brenda has taught thousands of students via public education television nationwide. In conjunction with each of her many television series, Brenda has authored instruction books by the same titles. To date Brenda has written more than a dozen instructional books and filmed more than 180 educational television shows. Her books, her classroom persona, as well as her paintings themselves, reflect her true joy of sharing and attention to detail.

Brenda believes no matter what your goals, a positive attitude is the most important tool of any trade. Brenda puts this positive approach into her teaching. She helps you realize that you too can become an artist! She says, "It's as easy as one-two-three.
First: Study the techniques necessary for the artwork of your choice.
Second: Practice until you have developed the skills to execute the techniques to your satisfaction.
Third: Achieve the goals you set for yourself."

Although Brenda's schedule is demanding, her favorite times still are those spent sharing and teaching in small paint-along workshops. "Nothing," she says, "replaces the one-on-one personal touch!"

Please visit Brenda on her web site: www.brendaharris.com.

About the Author

Painting with Brenda Harris, Volume 4: Gorgeous Gardens. Copyright © 2006 by Brenda Harris. Printed in Singapore. All rights reserved. No part of this book may be reproduced in any form or by any electronic or mechanical means including information storage and retrieval systems without permission in writing from the publisher, except by a reviewer who may quote brief passages in a review. Published by North Light Books, an imprint of F+W Publications, Inc., 4700 East Galbraith Road, Cincinnati, Ohio 45236. (800) 289-0963. First Edition.

fw
F+W PUBLICATIONS, INC.

Other fine North Light Books are available from your local bookstore, art supply store or direct from the publisher.

10 09 08 07 06 5 4 3 2 1

Library of Congress Cataloging-in-Publication Data

Harris, Brenda.
 Painting with Brenda Harris. Volume 4, Gorgeous gardens / Brenda Harris. -- 1st ed.
 p. cm.
 Includes index.
 ISBN-13: 978-1-58180-791-2 (pbk. : alk. paper)
 ISBN-10: 1-58180-791-0 (pbk. : alk. paper)
 1. Painting--Technique. I. Title. II. Title: Gorgeous gardens.
 ND1500.H344 2006
 751.4--dc22
 2006023853

Edited by Kelly C. Messerly
Art direction by Wendy Dunning
Cover designed by Sean Braemer
Interior layout by Kathy Gardner
Production coordinated by Jennifer L. Wagner

Distributed in Canada by Fraser Direct
100 Armstrong Avenue
Georgetown, ON, Canada L7G 5S4
Tel: (905) 877-4411

Distributed in the U.K. and Europe by David & Charles
Brunel House, Newton Abbot, Devon, TQ12 4PU, England
Tel: (+44) 1626 323200, Fax: (+44) 1626 323319
Email: mail@davidandcharles.co.uk

Distributed in Australia by Capricorn Link
P.O. Box 704, S. Windsor NSW, 2756 Australia
Tel: (02) 4577-3555

Metric Conversion Chart

To convert	to	multiply by
Inches	Centimeters	2.54
Centimeters	Inches	0.4
Feet	Centimeters	30.5
Centimeters	Feet	0.03
Ounces	Grams	28.6
Grams	Ounces	0.035

Dedication

I dedicate this book to all my painting buddies, my students, my teachers, my friends and family.

To my granddaughters, Breanna and Hollie Ann, I hope my hard work will inspire you to achieve your goals and enable you to enjoy a fulfilling life.

My husband, Roger Harris, has been my greatest supporter over the years. I dedicate this book to him and my daughter Jamie. Their extra help allowed me to concentrate on my book.

To my family and friends. I dedicate not only this book, but my success to you! Thanks!

Acknowledgments

Accolades go to many talented folks on the professional staff at North Light Books who work behind the scenes on my behalf. Special rave reviews go to Kelly Messerly, my editor; to Christine Polomsky, the photographer; and to my dear artist friend Este Rayle who assisted me. Kelly, Christine and Este worked hand in hand with me every step of the way in a totally cheerful, supportive and professional manner. The sessions were always full of laughter and cheer, making a seemingly arduous task a joy. Thank all of you for your unique part!

There are more folks than I have space to list that have had an impact on, and have contributed to my success as an artist, author and television teacher. I want to acknowledge you and express my gratitude to all of you. Even if your name is not in my dedication or acknowledgments, it does not mean that I am not appreciative of you and your influence.

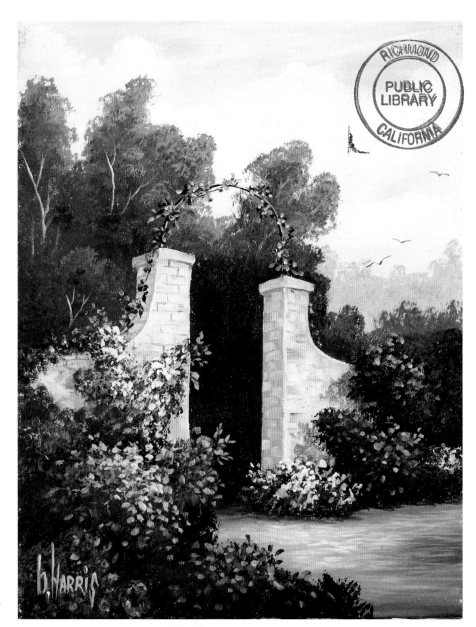

RICHMOND PUBLIC LIBRARY CALIFORNIA

I acknowledge my teachers, art buddies, seminar coordinators, students, and all the corporations who had confidence enough in me to finance my books and educational television programs. All have contributed to my success. You graciously welcomed me into your hearts and lives and have been a beacon to me. No matter what your role, I want to acknowledge and thank you for being there for me. I appreciate and treasure each of you.

Table of Contents

Acrylic Paint and Mediums

Acrylic Paint

You can paint the compositions in this book using fine art or student grade acrylic colors packaged in tubes or craft type colors packaged in squeeze bottles. For the most part, I prefer the tube colors as they have more body to their consistency and they tend to dry slower than the craft type acrylic colors packaged in squeeze bottles. Both types should be mixed and cleaned up with water. Use cool, clean water when mixing, painting with or cleaning up acrylic paints. Never use oils, thinners or turpentine with acrylics. If you want to slow the drying time, add Slowblend or a retardant medium to the water in your water container.

Select a brand that is easily accessible and affordable for you. You can set up your palette with colors from several different brands and combine bottled and tube acrylics on the same palette. Most of the colors will not be applied purely from the tube; instead, they will be tinted with white or toned by mixing with other colors.

When applied, acrylics dry at an uneven rate. Often the outer edges of an application begin to dry first; this can cause a spotty appearance. Usually, the color will even out and darken when it is completely dry. Speed the drying process with a hair drier held a few inches away from the canvas. Use a low temperature and keep moving the drier around the canvas.

Mediums

For the projects in this book, I have used three types of acrylic mediums that let you create beautiful color blends. There are a lot of different acrylic mediums besides these three—ask your paint supplier for recommendations, or contact me (brendaharris@brendaharris.com) to purchase these directly.

Whiteblend® is excellent for painting wet-into-wet and creating soft, subtle colors. Acrylic paint dries slower and blends better when mixed with it. It can also be used as white acrylic paint, or you can mix it with tube or squeeze bottle acrylic colors to tint them. Unless otherwise noted, all colors or mixtures in this book should have water or a medium added to them and be mixed to the same consistency as Whiteblend.

Clearblend® adds transparency to colors and dries flexible and water-resistant. It appears white in use but dries clear; it also is permanent when dry. Use it to create soft edges, transparent glazes and gradual blends and washes. Clearblend is frequently used to coat an area of dry paint before adding additional colors, allowing you to add and blend the additional colors using the wet-into-wet technique. Clearblend dries slower than acrylic tube or bottled colors and at the same rate as Whiteblend.

Slowblend® is a clear, slow-drying medium. It dries flexible but is less water resistant than Whiteblend or Clearblend. When applying paint to the canvas, Slowblend is used primarily to slow the drying time in the final layers and details. I add about ½ teaspoon per cup of water in my water container as I paint to slow the drying. In arid locations, I double the ratio. Mix no more than one part Slowblend to two parts paint; too much Slowblend can compromise the paint binder, which causes paint to lift easily from the canvas. Heavy use of Slowblend is not recommended when subsequent layers of paint are to be added.

Acrylic Colors

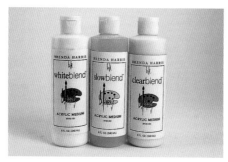

Mediums

Using a Palette and Mixing Colors

I use the Masterson Sta-Wet Super Pro palette system. It consists of a sponge sheet, special stay-wet palette paper and a durable storage container with a lid. Once you moisten the sponge sheet and paper and lay the palette paper over the wet sponge, you'll be ready to add colors.

I have listed "recipes" for mixing the colors for each project as a guide to assist you in mixing your colors. Please remember that recipes are approximate, mix your colors to your taste. Mix your colors so that they are pleasing to you, making adjustments to the mixtures' parts (about the size of a pea) to accomplish that.

Brenda's Palette

I use mostly student-grade acrylics. However, I have to buy some colors in professional grade because they are not available in student grade. Different brands may use different names for the same color. I have listed acceptable substitutes or the different names in parentheses.

Acrylic Colors
Acra Magenta/Violet (Phthalo [Thalo] Crimson or Thio Violet)
Burnt Sienna
Burnt Umber
Cadmium Red Light (Monoazo Orange)
Cadmium Red Medium (Grumbacher Red)
Cadmium Yellow Medium (Diarylide Yellow)
Cerulean Blue
Dioxazine Purple
Fleshtone Ceramcoat
Hooker's Green Deep (Sap Green)
Indiana Rose Opaque Ceramcoat
Magenta
Payne's Gray
Raw Sienna
Titanium White
Ultramarine Blue
Vivid Lime Green (Phthalo [Thalo] Yellow Green)
Yellow Ochre (Yellow Oxide)

Mediums
Clearblend
Slowblend
Whiteblend

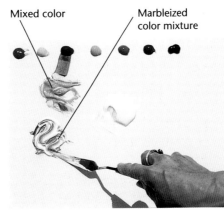

Mixed color Marbleized color mixture

Adding Paints to Your Palette

Squeeze out a marble-sized dollop of each color pigment (tube or bottle acrylic paint) to be used in your chosen project along the edge of your wet palette paper.

To store the mixed paint on your palette, carefully lift the paper off the sponge and lay it to one side. Remove the sponge and squeeze out the water. Replace the sponge, and then place the paper with the paint back on the sponge. Place the lid on the tray. Your paints will remain the same for several days. If you plan to save the paint longer and want to avoid a musty odor when you open the box, place the tray in the refrigerator.

Mixing Colors Using Your Palette

Before you begin each step, pre-mix your color mixtures for that step. Mix a larger amount of each color mixture than you think you will need. Save any unused mixtures on your palette, as you may need them later.

When pre-mixing your colors, use a clean, tapered painting knife to pull out the parts of the main color (largest portion listed). Mix, analyze and adjust the mixture until you achieve the color mixture you want.

Brush-Mixing

Often it is best to mix colors directly on the brush or paint applicator, such as the natural sea-wool sponge. This is referred to as brush-mixing, which is useful when you need a small amount of a color, to create and highlight foliage, or to create subtle value changes.

Whether mixing your hues with the palette knife or brush-mixing, leave your color mixtures slightly marbleized (slightly streaky). This will add interest and beauty to the color in your paintings.

Brenda's Basic Techniques

Throughout this book you will work with patterns (pages 100–109) that you will transfer to the canvas for each painting. In some projects you will also use design protectors. This page explains these two techniques.

Enlarging the Pattern

Use a copy machine to enlarge the patterns according to the percentages indicated or to fit any size canvas you choose to paint the composition on. Depending on the capability of the copy machine, it may require dividing the pattern onto two or more sheets of paper to make the design large enough. When more than one sheet of paper is required, align the papers so that the design is correct and tape them together.

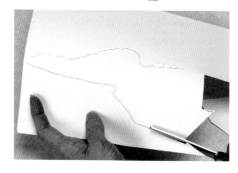

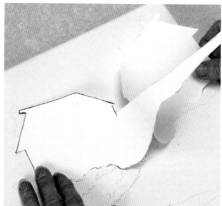

Using an Adhesive Design Protector

When you paint the background first, you'll often need to protect an area of your painting. Trace the outline of the area you need to protect onto a piece of label paper or any type of adhesive-backed paper (found at office supply stores), using the same technique as transferring a pattern. Cut out the image, remove the backing, align the design protector over the traced image and press it onto the dry canvas.

Paint carefully around the protector. Whenever possible, start with the brush on the protector, and stroke away from it, because stroking toward the design protector may force paint under it. When you're ready to paint the image under the protector, carefully peel the protector off the canvas.

Additional Supplies

Your choice of stretched canvas sizes
Adhesive-backed paper
(for design protectors)
Aerosol acrylic painting varnish with
ultraviolet protection
Bubble watercolor palette
Charcoal and white transfer paper
Cotton swabs
Hair drier
Large Sta-Wet Super Pro Palette System
Large water basin
Liquid soap
Kneaded eraser
Paper towels
Small, plastic containers (for mixing
glazes and to keep the mediums
separate from your palette)
Spray bottle
Stylus
Tape (either shipping, masking
or mending tape)
Toothbrush
Ultrafine-point waterproof permanent
marker or technical pen
(black or dark brown)

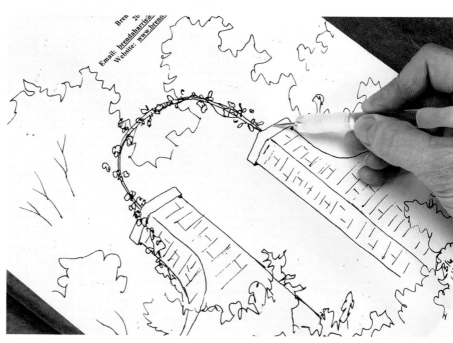

Transferring a Pattern

Lay the canvas on a flat, sturdy surface and tape the enlarged pattern firmly in place. Insert a piece of white or black transfer paper, powdery side down, between the pattern and the canvas. Trace the lines with a stylus or a ballpoint pen without any ink in it. While the pattern is still taped in place, lift a corner to check for missed lines.

Remove any visible transfer lines with a kneaded eraser or a clean, moist sponge after the painting has dried.

Brushes

Brushes come in different types and can come in a variety of bristle types. The most common bristle types you'll use in these projects are hog's hair (often called bristle brushes) and synthetic. Many brush manufactures make the same style of brush using the same bristle fibers but call it by a different size or proprietary name. For example, a no. 2 liner might be the same size as a no. 0 liner in a different brand.

If you have been painting for awhile, chances are you already have some brushes that will suffice for these projects; although, you may want to try some of the brushes I recommend if you want to augment your brush collection.

Most of the brushes listed here are from Royal & Langnickel Soft-Grip line. These brushes are an excellent value, are economically priced and are easily obtained at most art and craft stores and through most mail-order companies. However, you should experiment with all kinds of brushes to find the brands that suit you.

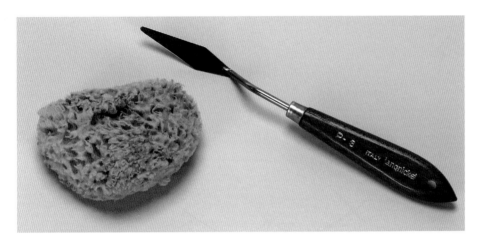

Additional Brushes
You'll also need a natural sea sponge and a palette knife.

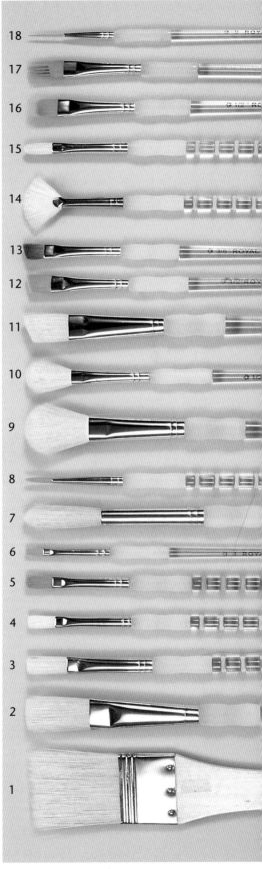

Brushes

You'll need these brushes to complete the projects in this book.

1. 2-inch (51mm) bristle flat
2. No. 12 bristle flat
3. No. 6 bristle flat
4. No. 2 bristle flat
5. No. 2 synthetic flat
6. No. 4 synthetic flat
7. No. 12 bristle round
8. No. 2 synthetic round
9. ¾-inch (19mm) mop
10. ½-inch (12mm) mop
11. No. 10 bristle angle
12. ½-inch (12mm) angle
13. ³⁄₈-inch (10mm) synthetic angle
14. No. 2 bristle fan
15. No. 2 bristle flibert
16. ½-inch (12mm) comb
17. ½-inch (12mm) wisp
18. No. 0 synthetic liner

Brush Techniques

For brushstrokes and techniques there are many terms that often mean different things to different artists. Following are the terms used in this book and definitions of corresponding techniques.

Applying and Removing Paint

Wet-Next-to-Wet. Apply two acrylic colors next to each other, slightly overlapping them. Blend them together where they overlap. This creates a gradual transition between the colors.

Wet-Into-Wet. Paint a base color or Clearblend directly onto the canvas, then apply one or more colors directly onto it. Blend the colors together quickly before they dry.

Wet-on-Dry. Apply and blend wet acrylic paint over dry acrylic paint. If the color or blend does not suit you, you can remove the wet color with a moist towel or sponge and try again without losing anything.

Wet-on-Sticky (Extremely Tricky). Avoid applying or blending wet paint in and around sticky (partially dry) paint. This technique is frustrating and difficult to control. Slick areas of buildup occur, and other spots lift off the canvas. When this happens, it is best to allow the paint to dry thoroughly; then touch it up by applying Clearblend over the area, then the appropriate colors, and blend.

Correcting Mistakes. Don't be afraid of making mistakes; we all do. Anything you put on your canvas can be corrected. Remove wet mistakes using a clean, damp sponge, paper towel or brush. If an error is stubborn to remove, gently agitate it with a toothbrush moistened with Slowblend, then wipe it away. If your mistake has dried, paint over it using Clearblend and the wet-into-wet technique. Or, would it be easier to simply cover it with foliage or a cloud? Train yourself to think creatively.

Correcting Mistakes

Side Loading

Double Loading a Liner Brush

Double-Loaded Liner Strokes
Position the no. 0 synthetic liner so that the highlight side of the brush (the lighter color) is toward the light source when painting.

Double Loading a Bristle Flat
This is a technique you will be using primarily to create grass, shrubs and bushes. Fill the brush with the foliage base color, then lightly pull the top of the brush across the color of the highlight or reflected light.

Working With Your Brushes

Loading a Brush. Have a large container of clean water handy to moisten your brushes before using them. Add ½ teaspoon of Slowblend per cup of water. Squeeze the bristles to remove excess water from large brushes; tap smaller brushes on a clean towel. To get a smooth application, load the brush from side to side. Moisten your brushes frequently while painting to ensure smooth, even coverage.

Side Loading. Load your brush with medium or water, then blot the excess on a paper towel. Dip one corner of the brush into your paint. Gently stroke the brush back and forth on a clean spot on your palette to create a gradation between the paint and water or medium. This should produce a graded color from bold at one end to neutral at the other. You can also side load your brush using white and a color or using two colors.

Double Loading. Apply two colors to the brush at one time. Generally load the brush with the darkest color of the subject, then pull one side of the brush through the highlight color to create a dark and a light side. Position the brush so the stroke is half dark and half light as you move along the canvas. This technique saves time when creating delicate details such as birds or tree limbs.

Crunching. Hold the brush perpendicular to the canvas, and press the tip of the brush against the canvas. Holding the brush in place, push slightly upward to bend the tips of the bristles downward and their centers upward; this makes the bristles flare out.

Stippling. Flare the brush before and during loading. Hold the brush perpendicular to the canvas, and pounce in the paint, causing the brush to flare open. Tap it against the canvas to apply random, tiny specks of paints.

Tapping and Patting. Angle the brush toward the canvas. Using less pressure than for crunching or stippling, lightly tap a small part of the brush tip on the canvas.

Crunching

Stippling

Tapping and Patting

Marbleize the Colors on a Double-Loaded Flat
With the highlight side of the brush turned down, paint an X mark on a clean place on your palette, creating various values and colors of the highlight in your brush.

Reshape a Flat for Stippling
With the marbleized highlight side of the brush turned upward, use light pressure to bend the sides of the brush downward to create an irregular rounded shape. Turn the highlighted side of the brush toward the light source when stippling highlights. Reload the brush frequently.

Painting Foliage

Depending on the look you want to achieve, crunch, stipple or tap to create the form and shape of foliage using its base color. I often crunch the basic shape of the foliage, then lighten the brush pressure to stipple and tap irregularly shaped foliage on its outer extremities. Use a combination of these techniques and a double loaded brush as shown on pages 10 and 11 to add reflected light and highlights to the foliage. Try a no. 12 bristle round or flat for large masses and the no. 6 bristle flat for smaller

areas. While the foliage is wet, anchor it to the ground using the base color and a clean brush moistened with Clearblend. Make the brushstrokes conform to the land as you stroke farther away from the foliage. If the base color begins to dry, apply some of your foliage base color horizontally across the ground at the root of the foliage mass, then blend the edges of the paint with a Clearblend moistened brush, conforming to the lay of the land.

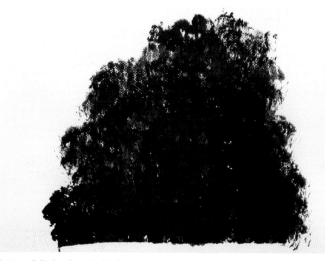

1 Establish the Foliage
Block in the foliage by crunching, stippling, or tapping with the base color, creating interesting shapes with leafy edges. Anchor the foliage to the ground. Let this dry.

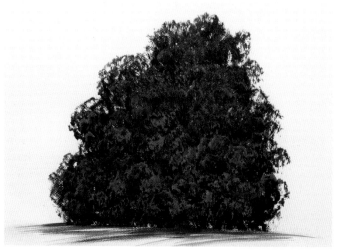

2 Add Reflected Light
Crunch, stipple or tap reflected light sparsely over the foliage, being careful not to paint solidly. Dry the reflected light.

3 Begin Highlighting
Highlight the top and outermost two-thirds area of the bush and foliage clusters, using a medium value of the foliage highlight color, again not painting solidly, just adding dabs.

4 Add the Sunlit Spots
Add additional dabs of sunlight on the top and outermost one-third area of the bush and clusters within.

Putting Clouds in the Sky

As well as foliage, skies and clouds are a major part of garden scenes. There are as many ways to paint skies as there are skies to paint! I am teaching some different techniques on painting skies and clouds in this book than in my previous books, mostly applying skies wet–on–wet.

I have learned that students are often not completely satisfied with their sky before it begins to dry and gets sticky. They fear that if their skies dry before they get the clouds painted to perfection, their painting will remain cloudless or be splotched and spotted forever. Should this happen to you, relax, dry your unfinished sky, then use this technique over the top of what you painted. No matter what shape your sky is in when it dries, you can transform and embellish it with clouds as beautiful as the heavens.

1 Establish the Sky
Loosely apply a generous amount of the sky's base colors with a different large bristle brush for each different color.

2 Add the Shadows
Quickly apply the cloud's shadow colors into the wet base color.

3 Blend the Colors
Blend the sky with a clean hake or duster (a soft, fluffy brush), and allow the sky to dry thoroughly.

4 Highlight the Clouds
Load one corner of a no. 2 bristle fan with White-blend and the other corner with a peach color. Place dabs of Whiteblend highlight with the fan wherever you want the top of a puffy spot on a cloud formation to be. Add a dab of peach within the highlight with the other corner.

Generously load a no. 12 bristle round with Clearblend and blot it on a paper towel. Hold the brush almost flat against the canvas, with the handle pointing away from the light source, and tap into the inside portion of the highlight, picking up some of the paint. Tap the brush randomly throughout the cloud to disperse the highlight. Move each subsequent stroke slightly toward the shadow, distributing less paint with each tap. Skip spaces to create multiple puffy spots, and blot to remove highlight if it's too solid. Scumble to end the highlight gradually and soften slightly with a light touch of a ¾-inch (19mm) mop to blend some, but not all, brush marks. Leaving lots of imperfections in the clouds is preferable to smoothly blending them.

Create extended formations by connecting several puffs to form large billows. Add puffy spots within the billows to bring the center portions forward. Continue until the sky is covered with clouds.

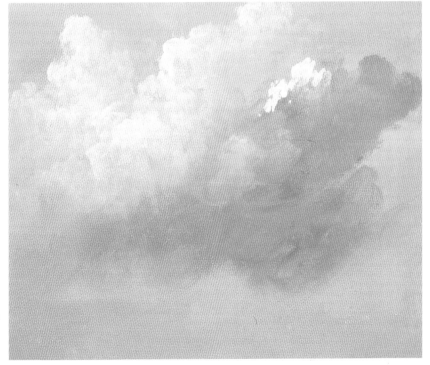

Welcome

Something within us loves a mystery, and as we approach this magnificent gate, our hearts beat a little faster in anticipation of what we'll find on the other side of its portals. We feel welcomed already! So come on in. Bring your paints and brushes, and we will have a fun-filled painting experience!

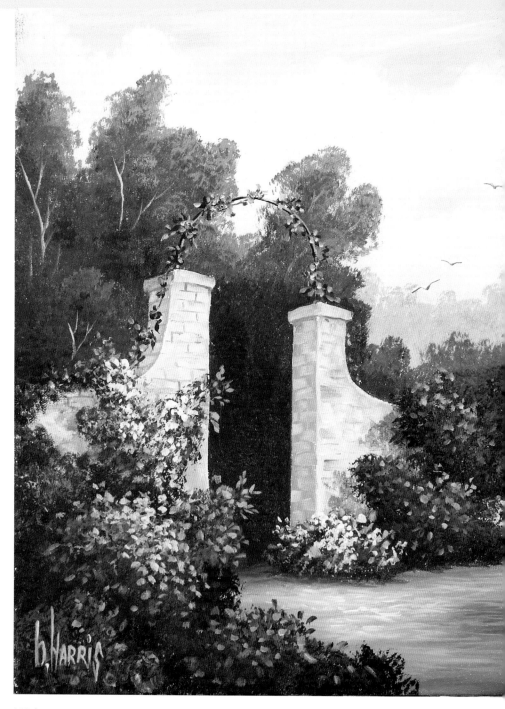

Welcome
Acrylic on stretched canvas
14" × 11" (36cm × 28cm)

Materials

Acrylic Colors
Burnt Umber, Cadmium Red Medium, Cadmium Yellow Medium, Cerulean Blue, Dioxazine Purple, Hooker's Green Deep, Payne's Gray, Raw Sienna, Titanium White, Ultramarine Blue, Vivid Lime Green, Yellow Ochre

Mediums
Clearblend, Slowblend and Whiteblend

Brushes
Nos. 6 and 12 bristle flats, no. 4 synthetic flat, no. 2 synthetic round, no. 12 bristle round, no. 0 synthetic liner, no. 2 bristle filbert, no. 2 bristle fan, no. 10 bristle angle, ½-inch (12mm) synthetic comb, ½-inch (12mm) synthetic angle, ¾-inch (19mm) mop, palette knife

Pattern
Enlarge the pattern (page 100) 154 percent

Other
14" × 11" (36cm × 28cm) canvas, ½ tsp. of Slowblend per cup of water, adhesive-backed paper, aerosol acrylic painting varnish, charcoal and white graphite paper, little plastic cups (for the mediums), scissors, stylus

Color Mixtures

Before you begin, prepare these color mixtures on your palette:

Marbleized Sky Blue	30 parts Whiteblend + 3 parts Ultramarine Blue + 1 part Cerulean Blue
Dark Green	1 part Hooker's Green Deep + 1 part Burnt Umber + 1 part Payne's Gray
Light Gray Green	5 parts Whiteblend + 1 part Dark Green mixture
Marbleized Mauve	1 part Light Gray Green + 1 part Cadmium Red Medium + 1 part Dark Green
Pale Peach	25 parts Whiteblend + 1 part Cadmium Red Medium + 1 part Yellow Ochre
Taupe	20 parts Pale Peach + 3 parts Whiteblend + 3 parts Payne's Gray + 1 part Dioxazine Purple + 1 part Raw Sienna
Marbleized Tan	6 parts Whiteblend + 4 parts Raw Sienna + 1 part Cadmium Red Medium
Violet Gray	4 parts Whiteblend + 3 parts Dioxazine Purple + 1 part Ultramarine Blue + 1 part Payne's Gray
Medium Green	1 part Dark Green mixture + 1 part Cadmium Yellow Medium + 1 part Whiteblend
Blue Green	2 parts Whiteblend + 1 part Cerulean Blue + 1 part Dark Green + 1 part Medium Green
Marbleized Yellow Green	4 parts Vivid Lime Green + 1 part Whiteblend
Violet Shadow	6 parts Clearblend + 1 part Dioxazine Purple + 1 part Ultramarine Blue + a touch of Payne's Gray

1 Apply Your Sketch

To make this pattern fit a 14" × 11" (36cm × 28cm) canvas, enlarge this sketch 154 percent, or enlarge it accordingly to fit the canvas size of your choice. Transfer the design to your canvas with charcoal graphite paper and a stylus. Make a design protector for the pillars, and place the cutouts over them.

2 Paint the Sky

Apply the Marbleized Sky Blue mixture in streaks across the top portion of the sky with the no. 12 bristle flat. Add Whiteblend to your brush, and lighten the value of the sky as you get closer to the horizon. Brush the paint back and forth to create gradual value changes and soft edges in the streaks. While this is wet, use the no. 10 bristle angle to apply the cloud formations, one at a time. Side load the long end of the angle brush with Whiteblend and use back-and-forth brushstrokes on your palette to gradually distribute the Whiteblend, with the longer bristles full of Whiteblend and the shorter bristles with none. Use the long end of the brush for the tops of the clouds, and move the brush in erratic, semicircular strokes to create puffy billows. Blend this into the wet sky with either the no. 2 bristle fan or no. 12 bristle round. Soften the brush marks with the ¾-inch (19mm) mop. Repeat this process for each cloud until you have all the clouds you wish.

Painting Clouds

Keep in mind that it is okay that your clouds look different from mine—all clouds have their own unique shape.

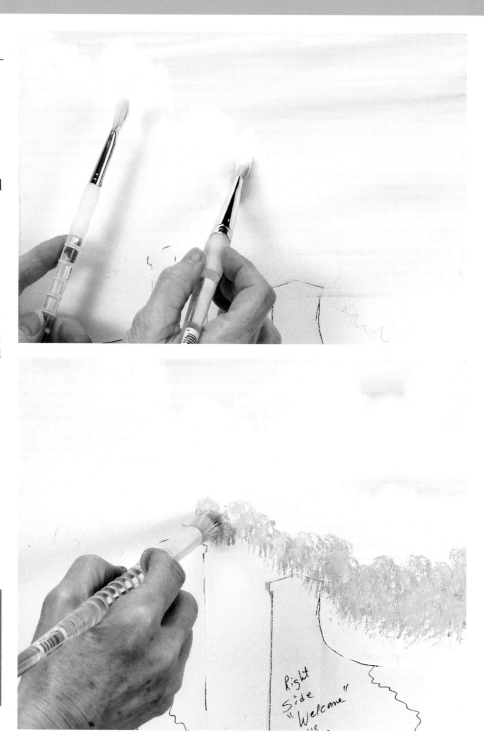

3 Add the Background Trees

Begin by using the no. 12 bristle round loaded with the Light Gray Green mixture. Lightly tap lacy edges along the tops of the trees, reloading your brush often (it's OK to paint over your design protector covering the pillar). Brush mix a little Whiteblend into the mixture to lighten the color if it seems too dark. The colors will dry darker, so use a lighter value of paint.

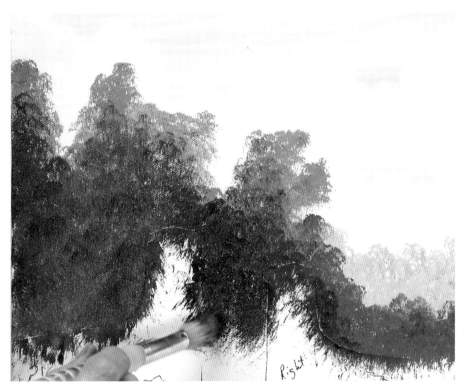

4 Add the Middle and Foreground Trees

With your uncleaned brush, mix in a touch of Dark Green, and begin stippling this into the midground foliage. Add more Dark Green incrementally to the uncleaned brush, making the foliage progressively darker as you move toward the bottom of the canvas, until the color is almost pure dark green between the columns. Make the tops of the middle trees overlap the bottom edges of the background trees (otherwise your background trees will look like they're floating in midair), and extend the trees to the side edges of your canvas.

5 Add a Rusty Tree on the Left and Highlights

With the uncleaned no. 12 bristle round, add Raw Sienna into the tip, and tap this to the tree on the left. Brush mix Marbleized Tan, White-blend and a little Raw Sienna. Double load this onto the brush, reshape, position the brush so the lighter side is up, then tap highlights into the top-right side of the tree's foliage. Wash your brush. Double load the brush with the Light Gray Green mixture and the Marbleized Mauve. Reshape the brush, and tap the Marbleized Mauve highlight onto the top right edges of the distant trees until it reaches halfway into the foliage clusters and trees. Add highlights to the remaining foliage, and wash your brush. Double load the brush with Pale Peach and Marbleized Mauve. Randomly tap lighter leaves just above the previous mauve tips on the most distant trees.

A Sticky Situation

If your paint starts to dry and become sticky, stop painting and dry it. Cover the area with Clearblend, and continue painting into the wet Clearblend, as wet-on-wet is easy, but wet-on-sticky is mighty tricky. This is because sticky paint will lift and leave little bare spots that are difficult to deal with.

6 Add the Twigs and Branches

Load the no. 0 synthetic liner with a mixture of Marbleized Mauve with a touch of Payne's Gray. Double load the liner with a mixture of Marbleized Mauve and Whiteblend. Apply the twigs from the bottom up by holding the brush so that the Whiteblend and Marbleized Mauve side is on the right and the darkened Marbleized Mauve is on the left. Blot the bottom of the wet twigs with your finger, making the twigs appear to recede into the foliage. Apply one twig at a time with this process.

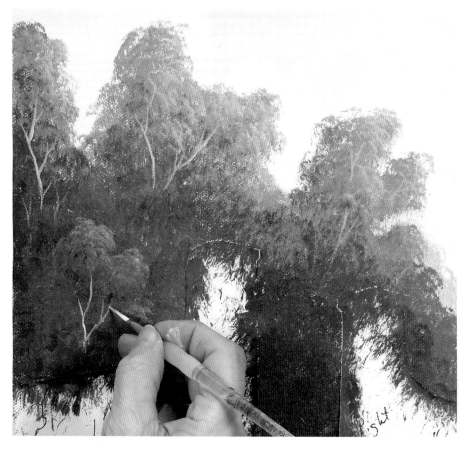

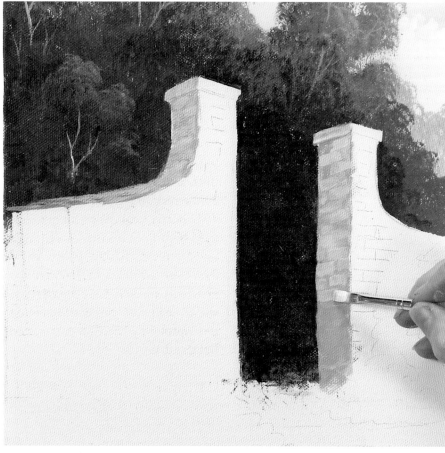

7 Paint the Shadow Sides of the Pillars

Remove the design protectors. With your ½-inch (12mm) synthetic angle, paint the shadow side of a pillar Taupe. While this is wet, add strokes of Pale Peach for the bricks with the flat side of the no. 4 synthetic flat. Repeat this process for the second column, making sure the paint is wet as you add the bricks so they have a soft appearance to them. If the Taupe begins to dry and your strokes appear too bold, randomly blot them to subdue.

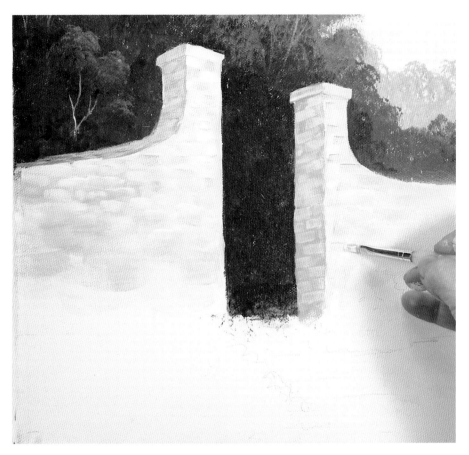

8 Paint the Light Sides of the Pillars

Paint the light sides of a pillar using Pale Peach and Marbleized Tan with the ½-inch (12mm) synthetic angle. Apply these mixtures alternately and randomly to the wall. While this is wet, add random dashes of lighter and darker Pale Peaches and Marbleized Tans to indicate bricks with the no. 4 synthetic flat. For darker bricks, add Taupe to the uncleaned brush, and use quick, loose strokes so your bricks do not look too perfect.

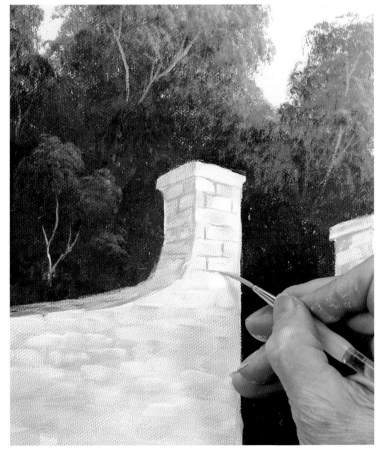

9 Add the Mortar Joints

Use the no. 0 synthetic liner and the Taupe mixture, thinned with lots of water, to randomly indicate some mortar joints on the light areas of the walls of the pillars. Randomly blot some of the mortar joints, leaving some subdued and others more distinct. If needed, separate some bricks on the shadow sides of the pillars with mortar joints using Taupe, darkened slightly with a touch of Marbleized Mauve in the same process you used to create the lighter mortar joints. Touch up any ragged edges with a clean no. 0 synthetic liner and the appropriate color for each area. Let this dry.

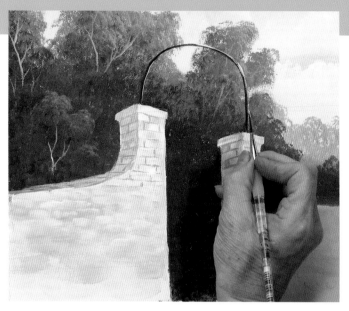
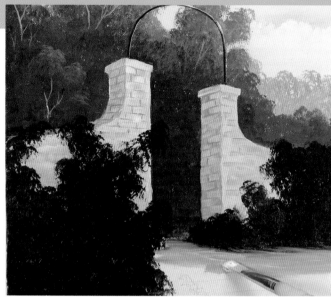

10 Add the Wrought-Iron Arch

Realign your pattern if necessary, and trace the arch with white graphite paper and a stylus. Paint the arch with a mixture of Payne's Gray thinned with water. (Remember, any time you use your no. 0 synthetic liner and need an ultra thin line, thin the paint with water so it is only slightly thicker than whole milk.) When the arch is dry, highlight it with your liner double loaded with a creamy Payne's Gray on one side and Whiteblend on the other. Hold the brush so the Whiteblend side is always on the right. The highlights add dimension and roundness to the arch.

11 Add the Foreground Foliage and Path

Stipple irregularly shaped foreground foliage and vines that overlap the front of the pillars, using the no. 12 bristle round and Dark Green. Soften the bottom edges of the shrubbery on the right with a ½-inch (12mm) synthetic comb dampened with water and Clearblend. Connect the shrubbery to the path using back-and-forth horizontal strokes.

Brush mix Raw Sienna and Whiteblend with the no. 6 bristle flat, and block in the path. Use short, choppy, horizontal strokes throughout to make sure the path and shrubs connect.

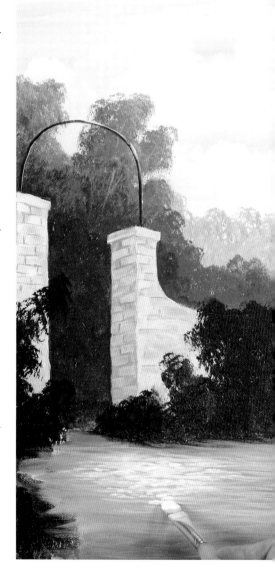

12 Add Shadows and Highlights to the Path

While the path is wet, darken the bottom portion of the path by adding Taupe and Violet Gray with the uncleaned brush. Follow the light and dark patterns in the finished painting as a guide. This makes the path appear to come closer to the viewer.

Hold the ½-inch (12mm) synthetic comb horizontally, and add highlights using short, choppy, horizontal strokes while the path is still wet. Brush mix Whiteblend and Raw Sienna, and apply various light values of this mixture in the path's center. Using the same brush, mix Titanium White and a touch of Yellow Ochre for the lightest highlights. As you apply the paint, leave textured ridges in the paint.

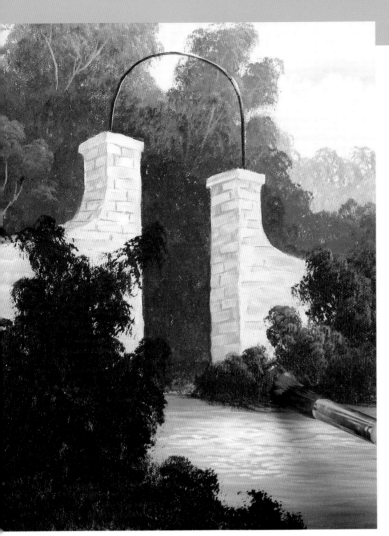

13 Form and Shape the Foreground Shrubs

Reshape the top edges of the shrubs by tapping lightly with the no. 12 bristle round loaded with Dark Green. Brush mix and double load Vivid Lime Green and a touch of Whiteblend into the top side of the uncleaned round, and use it to lightly tap highlights onto the top-right sides of the foliage clusters.

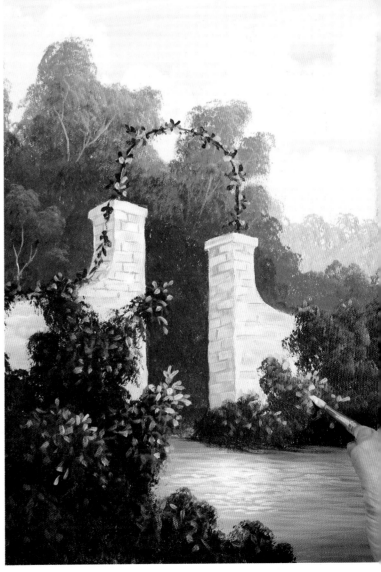

14 Add Vines to the Arch and Detail to the Shrubs

Add a vine climbing the arch with the no. 0 synthetic liner and Dark Green. Add individual leaves to the vine with the same brush, using each of the following mixtures, applied separately: Dark Green, Medium Green, Blue Green and Marbleized Yellow Green and Whiteblend. Add detailed leaves protruding from the shrubs with your no. 2 synthetic round, using the same colors applied individually as on the arch. Make the leaves on the arch and the shrubs turn all different directions, protruding in some places and not in others, concentrating the lightest values more heavily in the tops of the clusters nearest the light source. Let this dry.

15 *Add the Birds*

Apply small birds flying toward the middle tree, using the no. 0 synthetic liner with a mixture of Violet Shadow and a touch of Payne's Gray, double loaded with Whiteblend.

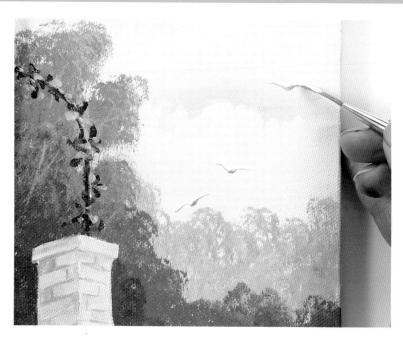

16 *Add the Flowers' Base Colors*

For blue flowers, brush mix Ultramarine Blue and Whiteblend, plus Cerulean Blue and Whiteblend. Apply dabbles of random clusters of deep values in the foliage. Add more Whiteblend to highlight the top of each cluster. Add shadows along the base and left side of each cluster with the base color and a touch of Dioxazine Purple. Follow this process for the other flower colors. For pinkish red flowers, use a base color of Cadmium Red Medium and a touch of Whiteblend. Add these to the arch, using the corner of the no. 4 synthetic flat. For the yellow flowers, use a base color of Yellow Ochre. Add a touch of Whiteblend to the Yellow Ochre for highlights and add Raw Sienna to the Yellow Ochre for shadows. For the orange-red flowers, use a base of Raw Sienna, Cadmium Red Medium and a touch of Whiteblend. Add Dioxazine Purple for the shadows, and highlight with a lighter value of the base colors using more Whiteblend.

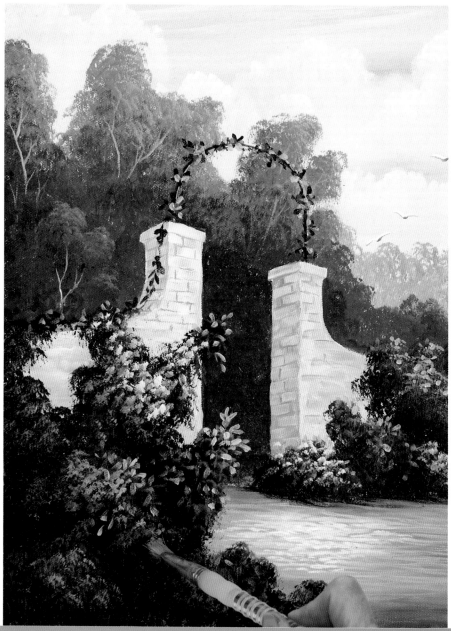

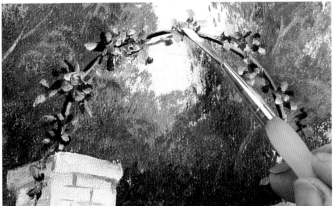

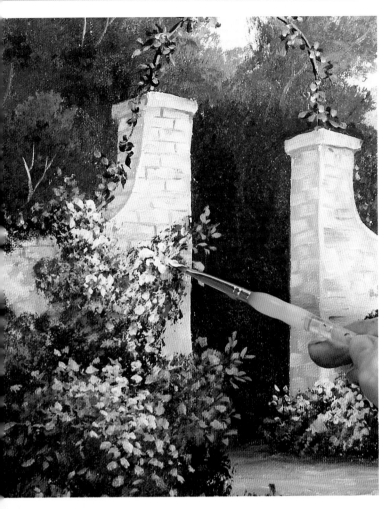

17 Add the Finishing Highlights to the Flowers and Foliage

Dab finishing highlights onto the top areas of the flower clusters with the no. 2 bristle filbert or no. 4 synthetic flat using a marbleized mixture of Titanium White and a speck of each flowers' base color. Clean the brush, and use Marbleized Yellow Green lightened with a touch of Titanium White to add a few brighter leaves in these areas. This adds interest and accentuates the focal point. Clean the brush, and add Blue Green and Medium Green leaves in the lower portions of the flowers' foliage.

18 Add the Final Detailed Leaves and Blooms on the Arch

Apply bright leaves randomly along the top and right sides of the arch, using the no. 0 synthetic liner or no. 2 synthetic round and Marbleized Yellow Green lightened with touch of Titanium White. Dry, then indicate individual roses in the vines' foliage with squiggly dabs of the pinkish-red mixture and Titanium White with the no. 0 liner.

19 Add the Flower and Shrub Shadows on the Column Walls

Smudge a shadow to the left of the foliage clusters on the column walls with the no. 6 bristle flat and the Violet Shadow mixture. Tap with your finger to subdue if it is too dark and to create soft ending edges. Sign and dry your painting, then spray it with a clear aerosol acrylic painting varnish. "Welcome" your family and friends to view your masterpiece!

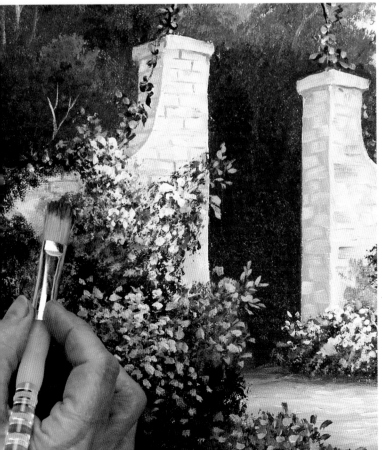

Southern Living

Expansive manicured lawns spread like thick carpet; gorgeous flowering shrubs along paths meandering in and out of the cool shadows; statuettes and stone columns; fluttering butterflies and gliding birds. This is a mental picture of Southern living not to be found anywhere else, no matter where you search.

So here's your opportunity to make that thought immortal. After you have completed this painting, paint another scene with two columns, one on each side of an entrance to a special place in your imagination, featuring flowers and trees that are dear to your heart. That is how you grow as an artist. Take the techniques you learn from your teacher, and go a step further. Give it a try, you can do it!

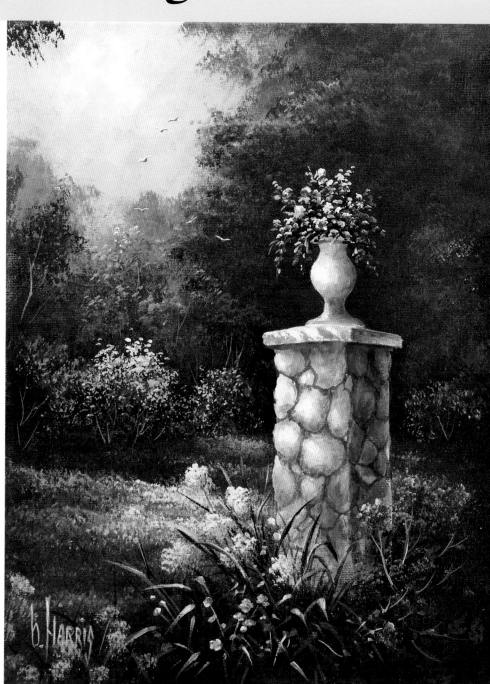

Southern Living
Acrylic on primed, stretched canvas
14" × 11" (36cm × 28cm)

Materials

Acrylic Colors
Burnt Sienna, Burnt Umber, Cadmium Red Medium, Cerulean Blue, Dioxazine Purple, Hooker's Green Deep, Payne's Gray, Titanium White, Ultramarine Blue, Vivid Lime Green, Yellow Ochre

Mediums
Clearblend, Slowblend, Whiteblend

Brushes
Nos. 2, 6 and 12 bristle flat, nos. 2 and 4 synthetic flat, no. 0 synthetic liner, no. 2 bristle fan, ½-inch (12mm) synthetic comb, ½-inch (12mm) synthetic angle, natural sea sponge, palette knife

Pattern
Enlarge the pattern (page 101) 154 percent

Other
14" × 11" (36cm × 28cm) canvas, ½ tsp of Slowblend per cup of water, adhesive-backed paper, aerosol acrylic painting varnish, charcoal and white graphite paper, hair dryer, little plastic cups (for the mediums), scissors, stylus

Color Mixtures

Before you begin, prepare these color mixtures on your palette:

Marbleized Cream	40 parts Whiteblend + 1 part Yellow Ochre
Off White	1 part Marbleized Cream + 1 part Titanium White
Marbleized Pink	50 parts Whiteblend + 1 part Cadmium Red Medium
Light Blue	4 parts Whiteblend + 1 part Ultramarine Blue
Violet	50 parts Whiteblend + 1 part Dioxazine Purple + 1 part Payne's Gray
Dark Green	1 part Burnt Sienna + 1 part Brunt Umber + 1 part Hooker's Green Deep
Medium Yellow Green	3 parts Yellow Ochre + 2 parts Whiteblend +1 part Hooker's Green Deep
Light Yellow Green	1 part Medium Yellow Green + 1 part Yellow Ochre + 1 part Vivid Lime Green + 1 part Whiteblend
Medium Blue Green	1 part Cerulean Blue + 1 part Hooker's Green Deep + 1 part Whiteblend
Light Blue Green	1 part Medium Blue Green + 1 part Whiteblend
Peach	5 parts Whiteblend + 4 parts Yellow Ochre + 1 part Cadmium Red Medium
Taupe	1 part Whiteblend + 1 part Burnt Sienna + 1 part Payne's Gray
Light Taupe	1 part Taupe + 1 part Whiteblend + 1 part Burnt Sienna

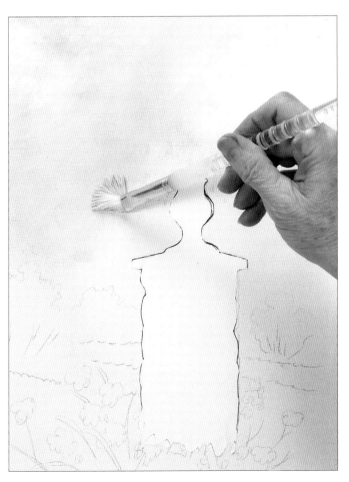

1 Apply the Design and Paint the Sky

Trace the pattern onto the canvas using gray graphite paper and a stylus. Omit the flowers, vase and foreground as you will trace them after the background is painted. Make a design protector for the column and vase, cut it out and place it over those images.

Using "slip-slap strokes," apply dabs of Marbleized Cream in the upper left area of the sky with your no. 2 bristle flat. Continue painting the sky by "slip-slapping" various values of Marbleized Pink around the Marbleized Cream with a no. 6 bristle flat, overlapping the edge of the Marbleized Cream and Marbleized Pink slightly where they join. Blend slightly by stroking back and forth between the colors, creating a gradual color transition, yet leaving a blustery, painterly appearance.

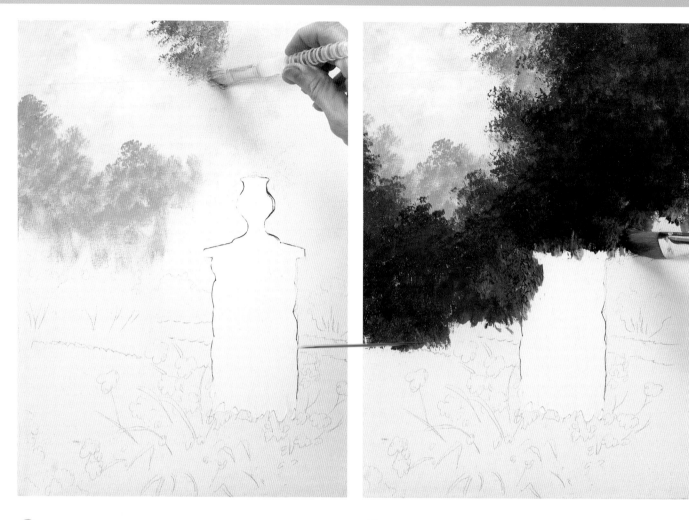

2 Add the Clouds and Most Distant Trees

Add Light Blue mixture to your uncleaned no. 6 bristle flat, and stroke clouds overlapping into the previously painted pink area of the sky while it is still wet. Use the same brush and mixture to stipple tree foliage around the outer edges extending down and into where the midground foliage will be. Wipe the excess paint from the brush, and blend some of the cloud strokes as needed, but leave the stippled tree shapes unblended. Add Violet to the uncleaned no. 6 bristle flat, and stipple a few distant Violet trees in the lower area of the tree shapes. Avoid painting over all the previous ones.

Loosen Up

If the paint becomes too thick and does not tap off the brush easily, add a touch of water to the paint to make it more manageable.

3 Add the Middle Ground Trees and Shrubs

Stipple the midground trees with your dirty no. 6 bristle flat and a variegated mixture of Light Blue, Dark Green and Burnt Sienna. Add Light Blue or Violet, should your mixture become too dark. Vary the mixture's color by using less Dark Green and more Burnt Sienna or vice versa. Stipple lightly to create lacy edges for the treetops, extending your paint into the next row of foliage.

Using your no. 12 bristle flat, stipple the top edges of the foremost trees in the background with Dark Green, overlapping the bottom edges of the midground trees. Add more Dark Green as you move down and out from the edges until the lowest portions of the background trees are almost pure Dark Green. Vary the color and value by picking up any of the individual colors of the Dark Green mixture.

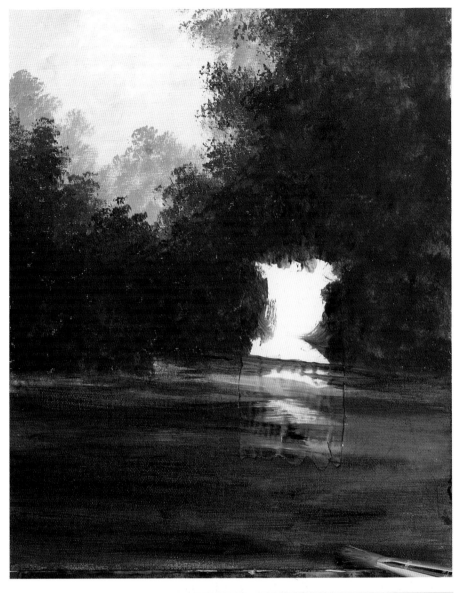

4 Connect the Background Foliage With the Ground, and Add Ground Shadow

Soften the bottom edges of the background shrubbery, connecting it to the ground, by stroking horizontally over the bottom edge with a ½-inch (12mm) synthetic comb.

Block in the ground shadows by making horizontal back-and-forth strokes with the no. 12 bristle flat, using Dark Green and adding water to thin the paint for lighter streaks across the ground. Continue this all the way to the bottom of the canvas.

5 Add Highlight and Reflected Light to the Distant Trees

Double load Medium Yellow Green to the top of the uncleaned no. 12 bristle flat, and crunch lacy highlights along the edges of the top-left side of trees and along the edges where you want to suggest treetops. Add Light Yellow Green to the top of the Medium Yellow Green side of the uncleaned brush. Crunch and tap the paint along the top side of the previously highlighted areas of the trees and along the foliage in the center of the distant foliage. Add Medium and Light Blue Green reflected light alternately to the top, side of the uncleaned brush, then stipple it along the right sides of the dark green distant tree shapes.

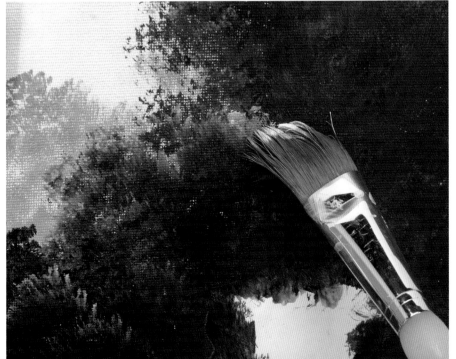

27

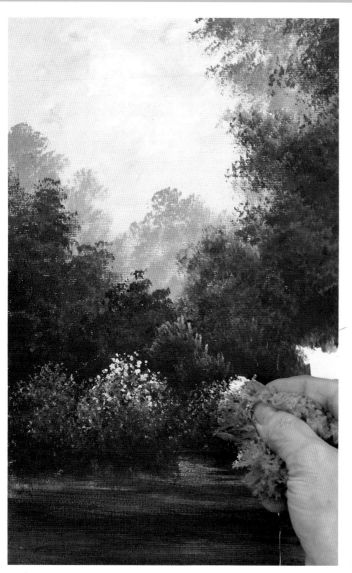

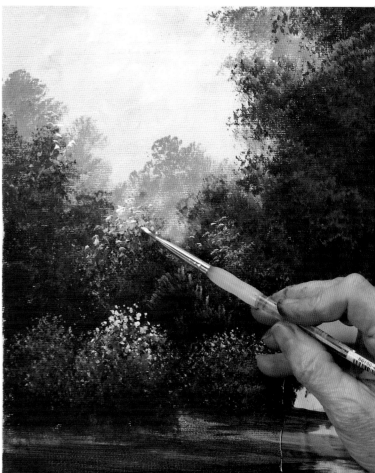

6 Add Blooms to the Low-Lying Shrubs

Load a small section of your natural sea sponge with Medium Blue Green, and tap in the shapes of the low-lying shrubs. Add a touch more Off White to the Medium Blue Green in the sponge to create a lighter value. Tap the lighter values in the top and middle portions of the shrubs to indicate tiny blooms. Add more White-blend to the color in the uncleaned sponge, and use it to tap along the top portions of the shrubs, indicating the most sunlit blooms. Blot the bottom of each color applied before adding the next to create a gradual transition of value in each color, with the shrub generally lighter on the top and the darkest values at the base.

7 Add the Pink Flowering Trees and Highlights

Stir some Cadmium Red Medium into the uncleaned sponge from the previous shrubs to create a dusty pink color, and tap this into some of the trees in the background. Add some Marbleized Pink to the uncleaned sponge, and tap lighter sunlit blooms in to the top portions of the medium value pink trees.

Add a few individual dabs of a highlights at the top edges of the pink trees with the no. 4 synthetic flat loaded with a marbleized brush mixture of Titanium White and pink mixture from the sky. Use a clean no. 4 synthetic flat to add Medium and Light Yellow Green leaves randomly at the edges of the opening. Do the same with the Light Blue Green and Titanium White, and add a few dabs of this highlight into the low-lying shrubs.

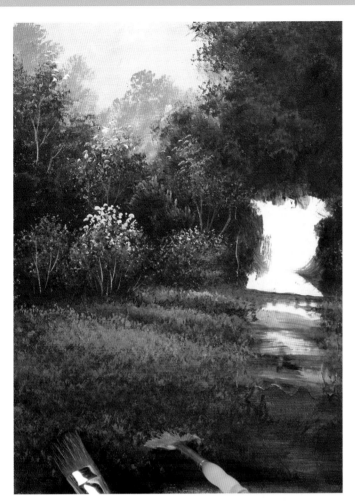

8 Add the Twigs, and Block in the Grass

Apply the twigs with a watery mixture of Burnt Umber in your no. 0 synthetic liner, double loaded with Peach. Hold the brush so the Peach mixture is on the sunny side of the twigs and limbs. Place the twigs so they cross over the shadows underneath the flowering trees and shrubs.

Use the no. 2 bristle fan and no. 12 bristle flat in tandem to crunch and tap sunlight and shadow grass colors over the ground shadows. Alternate between crunching Medium and Light Yellow Green grass streaks on the ground with the no. 2 bristle fan and stippling Dark Green shadow streaks with the no. 12 bristle flat. Work back and forth between the colors and brushes to create a gradual transition between the changes of colors. Remember to overlap the bottom of each streak of color with crunches, taps or stipples of the subsequent color.

9 Add Additional Highlights to the Grass

Double load Yellow Ochre and Whiteblend to the top side of the uncleaned no. 2 bristle fan, creating a light yellow. Then tap and crunch the light yellow highlight on the grass to create sunlit streaks. Blot the lower portions of the wet paint to recede it into the previous color, decreasing the vibrancy of the highlight at its bottom. Dry the canvas; use a hair dryer to speed the process, if needed.

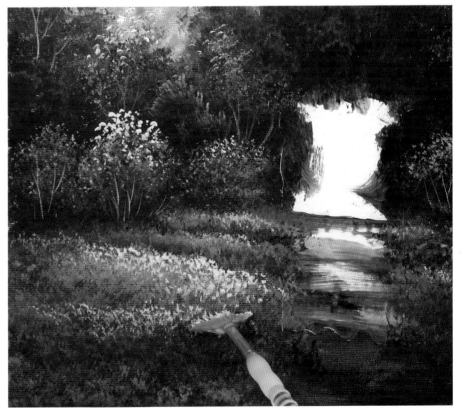

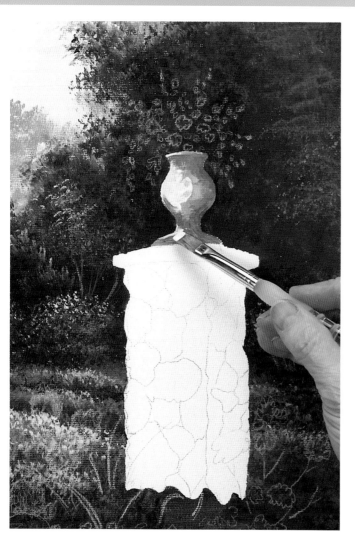

10 Paint the Vase

Remove your design protector, realign your pattern and use white graphite paper and a stylus to transfer the pattern of the column and the foliage and flowers in the vase. Paint the shadowy areas of the vase Taupe with the no. 2 synthetic flat. Add a touch of Payne's Gray to darken the Taupe slightly. Dabble this into the darkest areas of the vase, but do not go all the way to the right outer edge. Paint the sunlit side of the vase with a clean no. 2 synthetic flat and a mixture of Taupe lightened with White-blend and a touch of Burnt Sienna. Overlap this into the edge of the previously applied Taupe on the vase's shadow side. Add more Whiteblend, Burnt Sienna and a touch of the Peach to the uncleaned brush. Apply the lightened Taupe mixture in the most sunlit areas on the vase. Wipe the excess paint from the brush, and use it to tap and pat to blend the colors slightly but leave a mottled texture to the vase.

11 Add Final Highlights to the Vase

Using a clean no. 4 synthetic flat and Off White, dabble sunlight drifting at an angle across the vase. Wipe the no. 4 synthetic flat clean and tap and pat to blend the outer edges of the highlights, blending the colors slightly, but keeping a mottled texture to the vase.

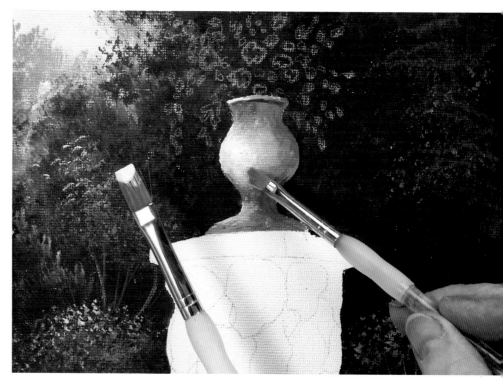

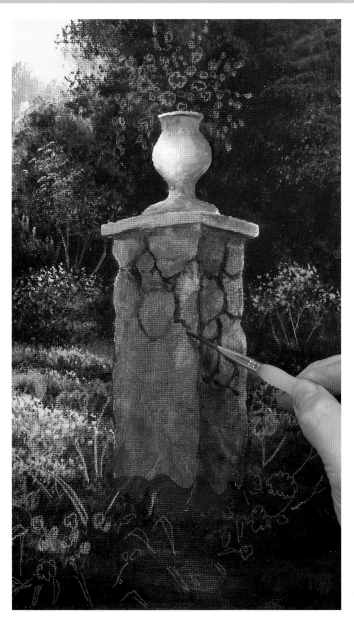

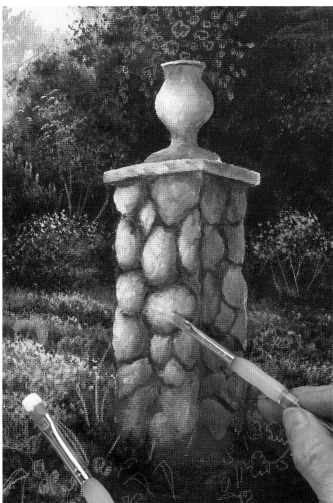

12 Block in the Shadows on the Column

Scrub a Light Taupe basecoating onto the light side of the column and flange with the ½-inch (12mm) synthetic angle. Scrub Taupe onto the shadow side of the column, the flange and the shadowy area under the flange. Use the no. 0 synthetic liner and thinned Taupe to draw irregular crevices between the stones on the light side of the column. Add a touch more Payne's Gray and water to the Taupe for the crevices on the shadow side and underneath the shadow side of the flange. Blot the crevice markings randomly to soften and add irregularity to the lines.

13 Highlight the Stones on the Column

Highlight and blend the stones one at a time, using two brushes in tandem. Apply the highlight on the lightest part of the stone with the no. 4 synthetic flat, then tap to blend the outer edges of the highlight toward the crevices with the no. 2 synthetic flat. Use Light Taupe for the highlights on the shadow side of the column. Brush mix various values of Light Taupe with various amounts of Marbleized Cream, Off White and an occasional touch of Peach for the highlight on the light side of the column. Do not clean the brush between color mixtures; control the colors and value of colors by varying the amounts of the different mixtures. Keep the lightest values concentrated at an angle across the light side of the column. Dry. If additional highlights or shadows are needed, moisten the area with Clearblend, then add and blend the color that you feel is lacking. If the Clearblend begins to get sticky before you're finished, dry, reapply the Clearblend and repeat as often as needed to reach the desired results.

14 Add the Ground and Vase Foliage

Use the no. 2 bristle fan and Dark Green to scrub irregularly shaped foreground foliage along the column's base. Draw leaves and stems out of that area and across the bottom of the canvas with Dark Green thinned with water and the no. 0 synthetic liner. Add leaves and stems to the vase with the uncleaned liner double loaded with Dark Green and Medium Yellow Green. Use the no. 4 synthetic flat to tap in Dark Green leaves between some of the blooms in the vase. Add lighter leaves with Light Yellow Green, using the tip of the no. 0 synthetic liner. Add Medium and Light Blue Green leaves to the shaded areas on the right of the bouquet with the same brush.

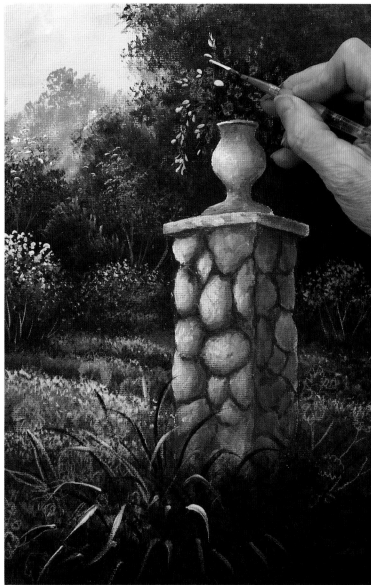

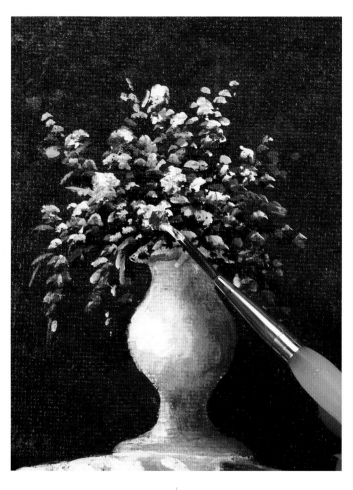

15 Add the Flowers in the Vase

Create Impressionistic roses and buds in the vase bouquet by applying squiggly globs of marbleized Cadmium Red Medium and Whiteblend, ranging from almost pure Cadmium Red Medium to almost pure Whiteblend in the bouquet. Randomly space the flowers and buds. Repeat this process to add some roses at the base of the column. Use Titanium White marbleized with a touch of Cadmium Red Medium for some of the larger blooms. Occasionally add a speck of Marbleized Cream to the mixture. Marbleize Peach with a touch of Titanium White for a few peach roses in the vase and at the bottom of the column.

16 Add the Foreground Flowers

Load the no. 2 bristle flat with Ultramarine Blue, then add Whiteblend to the top side. Pounce the brush up and down on the palette until the color is variegated in the brush from medium blue on the bottom to almost pure white on top. Use it to lightly stipple blue agapanthus blooms on some of the stems and throughout the foremost foliage. Reload, and pounce frequently to avoid solid blobs when stippling additional blooms. Add the red agapanthus blooms at the base of the column in the same manner using Cadmium Red Medium and Whiteblend.

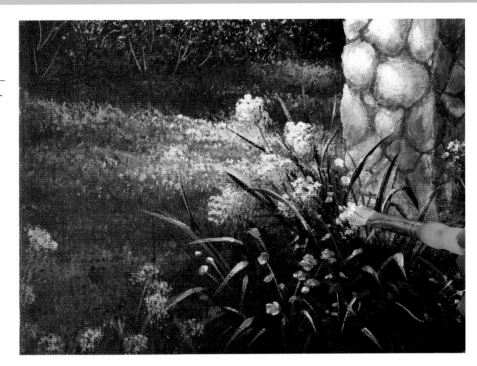

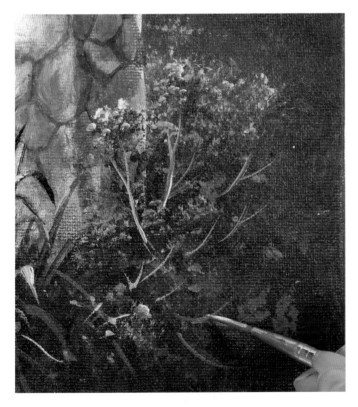

17 Add the Twigs and Stems

Double load the no. 0 synthetic liner with watery Burnt Umber on the bottom and Light Taupe on the top. Draw a few twigs and stems under some of the blooms.

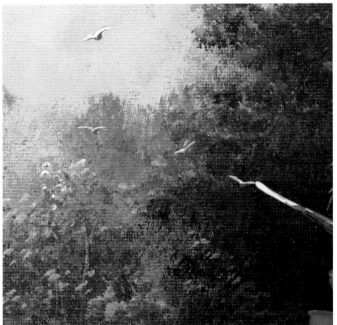

18 Add the Birds

Add tiny birds flying in with the no. 0 synthetic liner double loaded with Violet on the bottom and Whiteblend on the top, according to the technique on page 10. Sign and dry your painting, then spray it with an aerosol acrylic painting varnish. Sit back, and enjoy your interpretation of gracious "Southern Living."

3 Early Bird

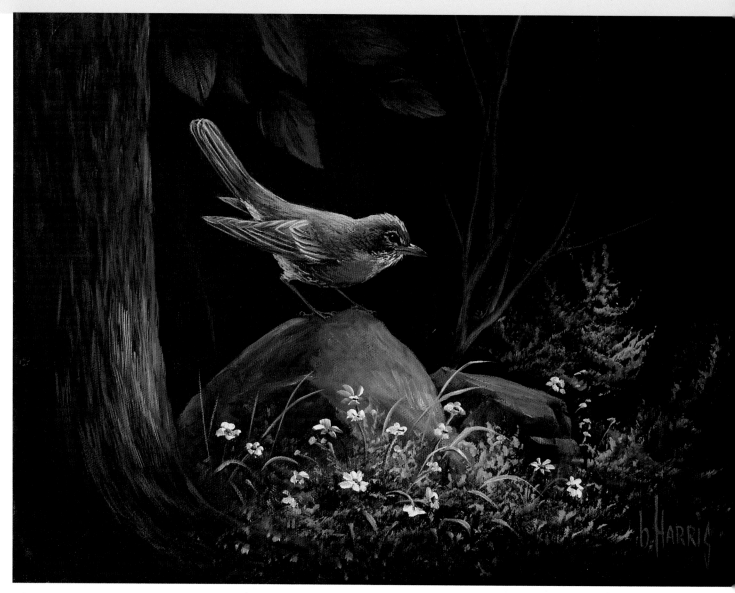

Early Bird
Acrylic on stretched canvas
12" × 16" (30cm × 41cm)

The first sign of spring has come to the garden. A frisky but stately robin searches for lunch. It could be an earthworm recently surfacing from winter's blanket or a choice of delectable bugs scurrying about among the tender green plants and the colorful buds opening in the warm sunshine.

That is his feast. I hope yours will be gobbling up all the fun techniques I have provided in this lesson. Think of how you can use these techniques in different ways. For example, you can use a dark background to create all sorts of compositions, from real life to still life. After completing this, take the techniques and venture out on your own; be the "early bird" of your unique masterpiece!

Materials

Acrylic Colors
Burnt Sienna, Burnt Umber, Cadmium Red Light, Dioxazine Purple, Hooker's Green Deep, Payne's Gray, Raw Sienna, Vivid Lime Green, Yellow Ochre

Mediums
Clearblend, Slowblend, Whiteblend

Brushes
2-inch (51mm) bristle flat, no. 2 bristle flat, no. 2 bristle fan, no. 4 synthetic flat, no. 0 synthetic liner, ½-inch (12mm) synthetic angle, ½-inch (12mm) synthetic comb, ½-inch (12mm) wisp, palette knife

Pattern
Enlarge the pattern (page 102) 170 percent

Other
12" x 16" (30cm x 41cm) canvas, ½ tsp. of Slowblend per cup of water, hair dryer, little plastic cups (for the mediums), scrap paper, stylus, white graphite paper

Color Mixtures

Before you begin, prepare these color mixtures on your palette:

Dark Brownish Green	brush mixture of Hooker's Green Deep + Burnt Umber + Burnt Sienna
Army Green	8 parts Yellow Ochre + 1 part Dark Brownish Green + 1 part Whiteblend
Avocado	4 parts Whiteblend + 3 parts Yellow Ochre + 2 parts Vivid Lime Green + 1 part Army Green
Dark Taupe	3 parts Whiteblend + 2 parts Burnt Sienna + 1 part Payne's Gray
Dusty Violet	20 parts Whiteblend + 1 part Payne's Gray + 1 part Dioxazine Purple
Warm Taupe	1 part Dark Taupe + 1 part Burnt Sienna + 1 part Whiteblend
Marbleized Dark Brown	3 parts Burnt Umber + 2 parts Whiteblend + 1 part Payne's Gray
Orange	brush mix 2 parts Cadmium Red Light + 1 part Yellow Ochre + 1 part Whiteblend

1 Prepare the Canvas

Brush mix a Dark Brownish Green background color. Add the colors alternately so they have a mottled appearance. Adjust the component parts so the area where the bird will be is a brownish black color. Scrub the paint onto the canvas briskly, applying enough pressure to shove the paint deep into the pores with the 2-inch (51mm) bristle flat. Occasionally add a touch of water to the brush so the paint will spread easily. Use a hair dryer to dry this quickly. Use white graphite paper and a stylus to transfer the pattern onto the background.

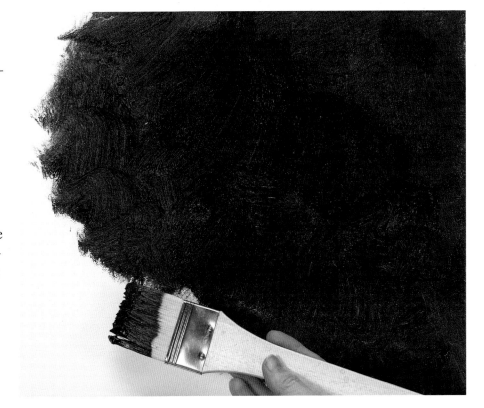

2 Paint the Rocks and Background Twigs

Moisten the rocks with Clearblend on the no. 2 bristle flat and apply the rocks colors into the wet Clearblend. Soften some of the edges of your brushstrokes with the no. 2 bristle flat moistened with Clearblend. Slip–slap Marbleized Dark Brown over the moist rocks using the ½-inch (12mm) synthetic angle, following the crevices to create shadows, form and shape. Leave the rocks variegated and mottled. Double load Dusty Violet on top of the uncleaned brush and add some dashes of reflected light in the shadowy areas of some rocks. Highlight the right side and tops of the flat rocks with Warm Taupe loaded on the Dusty Violet side of the uncleaned brush, making the strokes follow the crevices and rock shapes. Lighten the Warm Taupe with a touch more Whiteblend for the sunniest spots. Thin Marbleized Dark Brown with water and add some twigs in the background using the no. 0 synthetic liner. Blot the root areas of each twig as you progress to recess its base into the foliage.

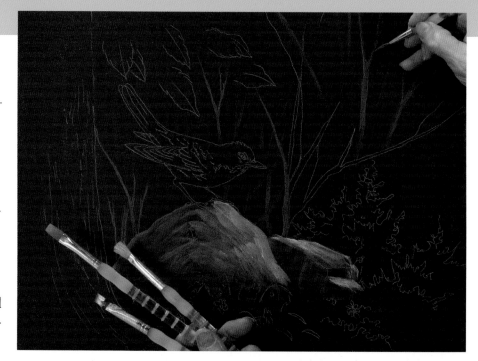

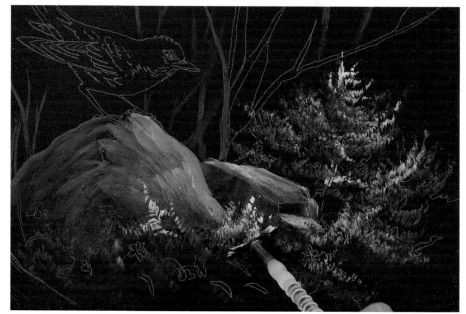

3 Stipple the Foliage

With a piece of paper, shield the distant rock as you add the foliage behind it. Double load the no. 2 bristle fan with Army Green on the bottom and Avocado on the top. Crunch foliage behind the distant rock, twisting the brush up at the corners. Brush mix Yellow Ochre, Raw Sienna and a touch of Whiteblend into the top of the uncleaned brush, and add a few highlights on some foliage. Add Vivid Lime Green and a touch more Whiteblend to the top of the uncleaned brush, and add a few highlights to the tips of some foliage. Move the protector. Rinse the brush, and reload it with Army Green and Avocado. Repeat this process to add foliage in front of the rocks. Experiment with brush mixing, changing the proportions of the components of the foliage colors to create different values and colors of the foliage and highlights.

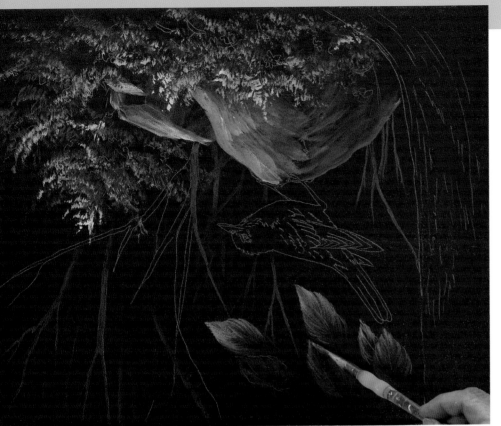

4 Add Leaves Behind the Bird

Turn your canvas upside down. Apply the tree leaves using a thinned, marbleized Army Green mixture with the ½-inch (12mm) comb. Apply the paint in strokes from the outside of the leaf inward, following the direction and shape of each individual leaf. Let streaks of the background color show through to indicate veins. Decrease the amount of paint you use as you move toward the stem of the leaf. Blot, if necessary, to make the stem portion of each leaf disappear in the shade of the tree.

5 Add the Tree Bark

Brush mix Payne's Gray, Burnt Umber, Burnt Sienna and Whiteblend with the ½-inch (12mm) wisp. Vary the amounts of the pigments for a range of light and dark browns. Hold the ½-inch (12mm) wisp vertically, and make short, choppy strokes to create the bark's texture, beginning at the edge of the canvas and working towards the center. At the tree's center, add a touch more Burnt Sienna and Whiteblend to the uncleaned brush, and continue toward the right side of the tree. Add a touch each of Burnt Sienna, Cadmium Red Light and Whiteblend to the uncleaned brush. Add a sunlit area across the lower portion of the tree. Add Raw Sienna and Whiteblend to the uncleaned brush to lighten further.

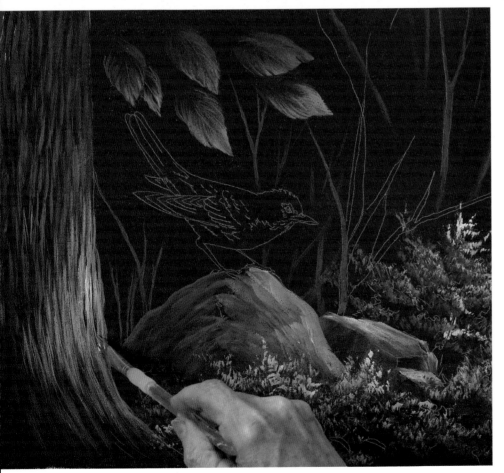

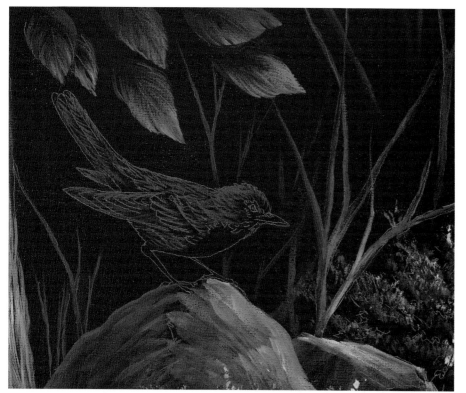

6 Add the Foremost Twigs

Add the foremost twigs to the right of the distant rock, using the no. 0 synthetic liner, double loaded with the dark browns from the tree on the left side of the liner and the lighter tree values on the right. Make sure the lighter browns are applied to the twigs' light sides. Add depth to the painting by making the foreground twigs larger and giving them more highlights than the background twigs.

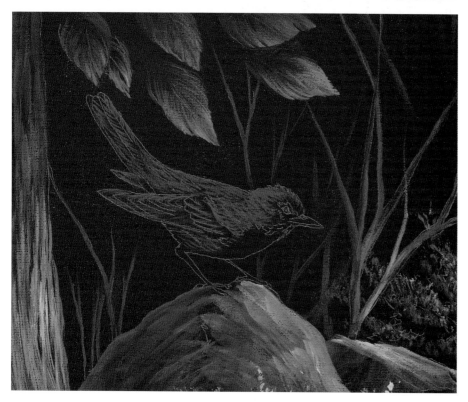

7 Apply a Basecoat to the Bird

Apply the first layer of feathers with Dark Taupe using the ½-inch (12mm) wisp. Move the brush according to the direction of the feathers' growth, and start at the tip of the feather and stroke back toward the body. Touch and pull short strokes, and repeat to create the illusions of layered feathers. Add the second layer of feathers in the same manner using the wisp and Warm Taupe. Apply this randomly over the body, especially on the top of the shoulder, the head and the side of his rump. Incrementally add White-blend, creating various values. Apply these on the top of the back, his head, his sit-upon, and his chin.

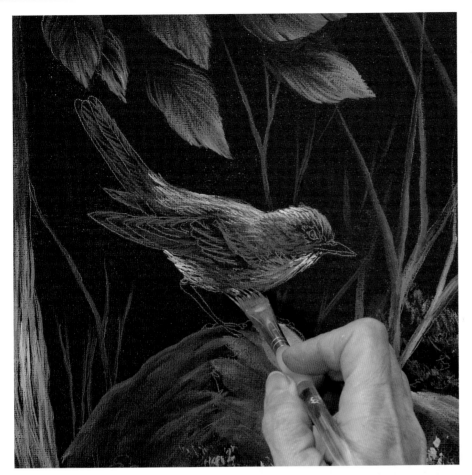

8 Add Feathers to the Belly

With the clean ½-inch (12mm) wisp, start with Burnt Sienna on his belly, and add Cadmium Red Light to the uncleaned brush as you come toward his throat. Add Cadmium Red Light and a touch of Whiteblend to a clean ½-inch (12mm) wisp to make the upper portion of his chest brighter. Add Yellow Ochre and Whiteblend to Cadmium Red Light for the lightest feathers on the side of his throat.

9 Tidy Up the Bird's Body

Use Warm Taupe with the no. 0 synthetic liner to tidy up the bird's body. Use the uncleaned liner and the Warm Taupe to create the outer edges and barbs of the tail feathers. Add the quill on the top tail feather with the Warm Taupe. Apply dashes of this color randomly in the tail feathers. Continue with the Warm Taupe and no. 0 synthetic liner to separate the tail feathers from the tips of the background wing. Use the same brush and colors to define the primary and secondary wing feathers at the bird's side, using the same techniques you used for the tail feathers.

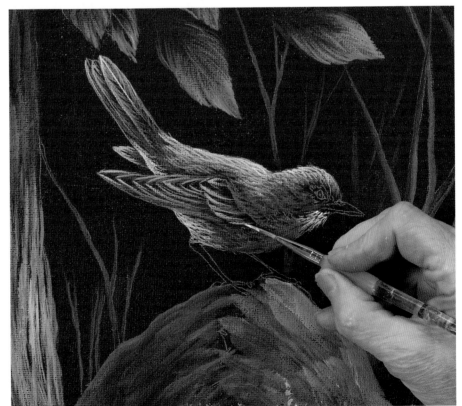

10 *Paint the Eye*

Paint the eye Burnt Umber with a clean no. synthetic 0 liner. Add Burnt Sienna and Whiteblend to the liner and make a half circle for the bottom half of the eye. Paint the pupil in the center of the eye with Payne's Gray on a clean no. 0 synthetic liner. Dry. Add a dot of Whiteblend for a catchlight, positioned at 11 o'clock between the iris and the pupil. Add the tiny feather markings around his eye using a clean liner and Warm Taupe.

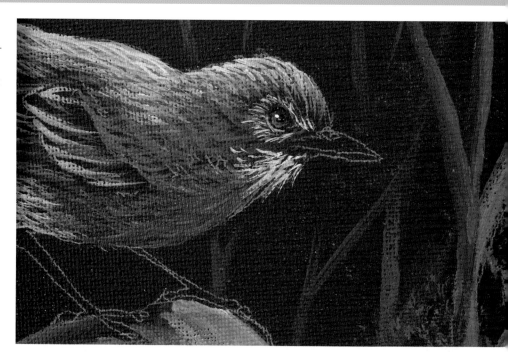

11 *Add the Beak and Legs*

Paint his beak using a no. 0 synthetic liner with Orange, using strokes that follow the shape of the beak. Lighten the Orange with a touch of Whiteblend, and highlight the top edge of his beak. Using a clean no. 0 synthetic liner, add a bit of Burnt Umber to the Orange, darken the tip of his beak and draw a separation between the beak's top and bottom parts.

Use a cleaned no. 0 synthetic liner to paint his feet and legs with the medium-value colors from the rocks or tree. With the clean liner, streak some Dusty Violet on the undersides of his legs. Paint his claws with Payne's Gray on a clean liner, and add a hint of highlight with the Dusty Violet.

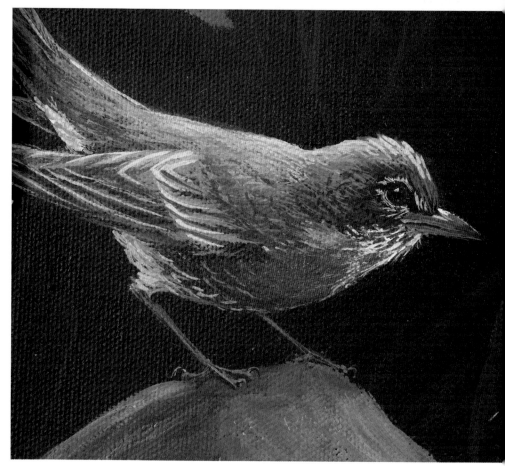

12 Add Grass Along the Rocks

Crunch the foremost foliage in front of the large rock with a no. 2 bristle fan double loaded with Army Green on the bottom and Avocado on the top. Brush mix Yellow Ochre, Raw Sienna and a touch of Whiteblend into the top side of the brush and add highlights. Add Vivid Lime Green and a touch more Whiteblend to the top of the brush and add a few bright green highlights in the most sunlit areas. Change the proportions of the components of the foliage colors to create different values of foliage highlights.

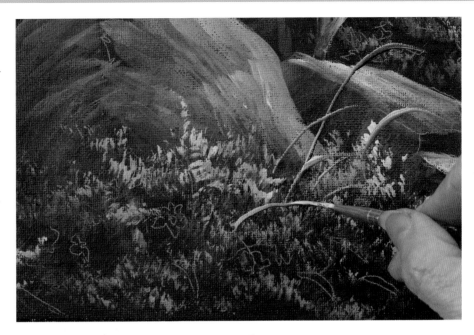

13 Add Some Flowers

Use the no. 4 synthetic flat double loaded with Warm Taupe on the bottom and Whiteblend on the top; stroke in the foreground flower petals. Make the petals irregularly shaped and create several sizes of blooms facing different directions. Dab a stamen into the center of the flowers with a clean no. 4 synthetic flat, double loaded with Burnt Umber on the bottom and Raw Sienna and a touch of Whiteblend on the top. Sign your painting. Dry your canvas thoroughly with a hair dryer. Spray your painting with aerosol acrylic painting varnish and enjoy your "Early Bird."

Removing Graphite Lines

Should any of your graphite lines remain visible, erase them with a kneaded eraser or a clean, moist sponge.

Grandma's Little Gardener

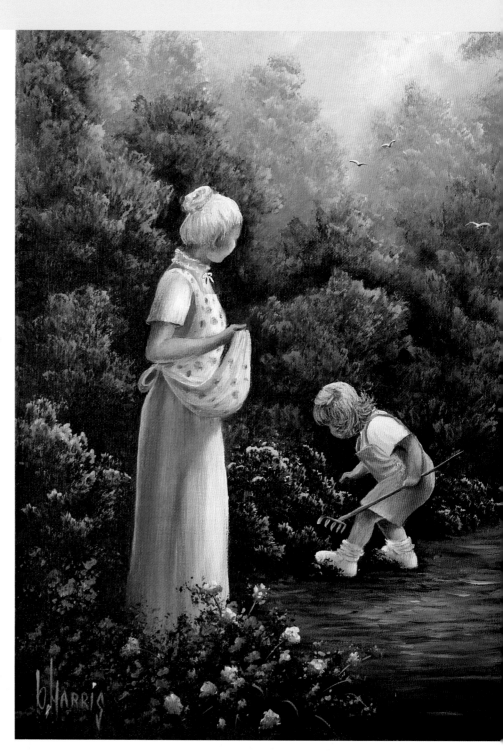

Any grandmother will tell you that being a grandmother is twice the joy of being a mother. Many say, "I wish I had had my grandchildren first; I would have enjoyed my children more!" Who knows what the magic is? Nevertheless, Grandmas are experts on "making memories" and know that any chore is more fun when you have a helper. Even when that "bit of help" creates more work, it is a joyous labor of love.

As an artist, approach your painting experiences with the wondrous exuberance of a child in the garden for the first time. Check everything out! In this composition, feel free to alter the colors of hair, clothing or sizes of figures to portray your loved ones. I will be like the grandmother, enjoying every moment of your exploration, standing by with proven techniques, guiding you as you fearlessly explore and grow as an artist and accomplish your goals.

Grandma's Little Gardener
Acrylic on primed, stretched canvas
20" × 16" (51cm × 41cm)

Materials

Acrylic Colors
Acra Magenta, Burnt Sienna, Burnt Umber, Cadmium Red Light, Cadmium Red Medium, Cadmium Yellow Medium, Cerulean Blue, Dioxazine Purple, Hooker's Green Deep, Indiana Rose Opaque Ceramcoat, Payne's Gray, Raw Sienna, Ultramarine Blue, Vivid Lime Green, Yellow Ochre

Mediums
Clearblend, Slowblend, Whiteblend

Brushes
2-inch (51mm) bristle flat, nos. 2, 6 and 12 bristle flat, nos. 2 and 4 synthetic flat, no. 12 bristle round, no. 0 synthetic liner, ¾-inch (19mm) mop, ½-inch (12mm) synthetic comb, ½-inch (12mm) synthetic angle, ½-inch (12mm) wisp, palette knife

Pattern
Enlarge the pattern (page 103) 175 percent

Other
20" × 16" (51cm × 41cm) canvas, ½ tsp. of Slowblend per cup of water, adhesive-backed paper, aerosol acrylic painting varnish, charcoal graphite paper, little plastic cups (for the mediums), scissors, stylus

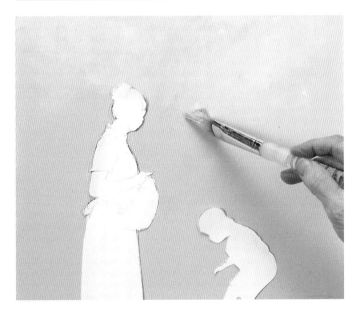

Color Mixtures

Before you begin, prepare these color mixtures on your palette:

Marbleized Cream	Whiteblend + a touch of Yellow Ochre
Various Values of Pink	20 parts Whiteblend + various amounts of Cadmium Red Light
Sky Blue	20 parts Whiteblend + 1 part Ultramarine Blue
Dark Green	2 parts Hooker's Green Deep + 1 part Burnt Umber + 1 part Burnt Sienna
Pastel Greenish Blue Gray	2 parts Sky Blue + 1 part Dark Green
Medium Green	1 part Pastel Greenish Blue Gray + 1 part Dark Green
Avocado	2 parts Whiteblend + 1 part Hooker's Green Deep + 1 part Yellow Ochre + 1 part Vivid Lime Green
Yellow Green	1 part Medium Green + 1 part Yellow Ochre + 1 part Whiteblend
Khaki	2 parts Raw Sienna + 1 part Whiteblend
Terra Cotta	1 part Cadmium Red Light + 1 part Whiteblend + 1 part Raw Sienna
Burnt Sienna Wash	2 parts Clearblend + 1 part Burnt Sienna
Peach	20 parts Whiteblend + 1 part Cadmium Red Light + a touch of Cadmium Yellow Medium
Cadmium Red Light Glaze	2 parts Clearblend + 1 part Cadmium Red Light
Denim	1 part Ultramarine Blue + 1 part Whiteblend + a touch of Payne's Gray
Off White	4 parts Whiteblend + 1 part Marbleized Cream
Light Cerulean	10 parts Whiteblend + 1 part Cerulean Blue
Purplish Violet	3 parts Whiteblend + 1 part Dioxazine Purple + 1 part Ultramarine Blue
Clearblend/ Whiteblend Wash	3 parts Clearblend + 1 part Whiteblend
Marbleized Reddish Purple	2 parts Dioxazine Purple + 2 parts Acra Magenta + 2 parts Cadmium Red Medium + 1 part Whiteblend
Teal	1 part Cerulean Blue + 1 part Vivid Lime Green + 1 part Ultramarine Blue + 1 part Whiteblend

1 Prepare the Canvas, and Paint the Sky and Background Trees

Basecoat the canvas using Indiana Rose Opaque Ceramcoat and the 2-inch (51mm) bristle flat. Trace the pattern onto the canvas with charcoal graphite paper and a stylus. Create design protectors for the figures, and place these over their corresponding images on the canvas.

Paint the sky using slip-slap strokes and the no. 6 bristle flat. Work from the lightest point outward. Use dabs of Marbleized Cream on the top right. Add Pink to the uncleaned brush, and continue outward, blending the Marbleized Cream and Pink where they meet. Cover the sky beyond the distant treetops. Add Sky Blue to the uncleaned brush. Stipple cloud and tree shapes, overlapping into the Pink. Extend the color into the midground. With the ¾-inch (19mm) mop, lightly blend the clouds. Leave other shapes intact to indicate distant treetops.

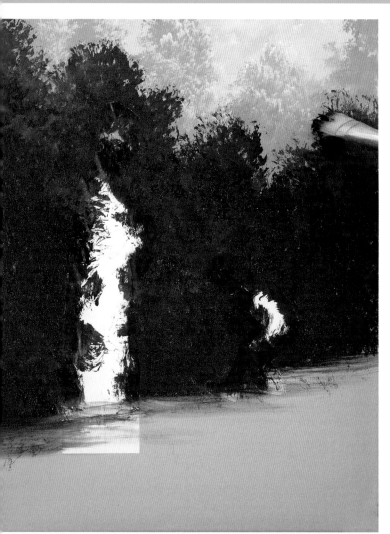

2 Add the Middle and Foreground Trees

Stipple in the midground trees, using the no. 12 bristle flat loaded with Pastel Greenish Blue Gray. Double load the top of the uncleaned no. 12 bristle flat with Peach, and crunch highlights on the top-right sides to indicate sunlit branches.

Wipe the excess Peach from the brush, and add Dark Green to the Pastel Greenish Blue Gray for the closer, darker trees and shrubs. Tap and crunch the trees and shrubs behind the child and grandmother. Anchor the trees to the ground around the child and grandmother's feet by stroking the bottom edge of the wet trees' paint back and forth horizontally with a ½-inch (12mm) synthetic comb dampened with water and Clearblend.

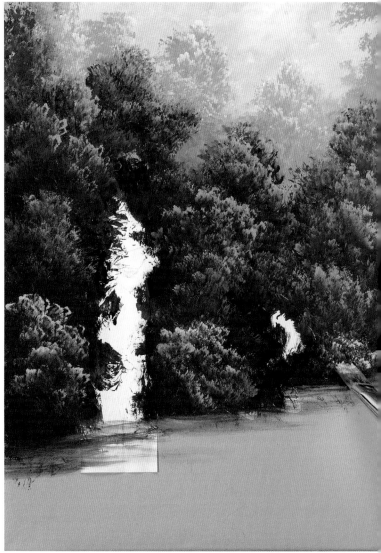

3 Add the Reflected Light and Highlights

Double load the top of the uncleaned no. 12 bristle flat with Teal, and crunch reflected light randomly into the trees and shrubbery. Highlight some limbs on the top-right side of these trees by double loading Avocado onto the Teal side of the uncleaned bristle flat. Crunch this randomly on the top and right sides of the middle trees. Add Yellow Green to the Avocado side of the uncleaned brush, and crunch this slightly onto the top and right sides of the shrubs.

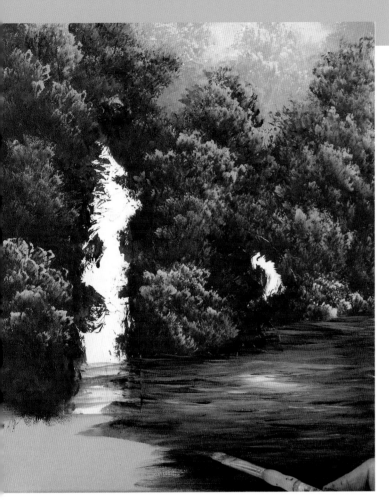

4 Paint the Soil

Coat the ground in horizontal back-and-forth strokes, using Burnt Umber thinned with water and a no. 6 bristle flat. Darken the deepest shadows, using the same brush and more Burnt Umber with alternating touches of Dioxazine Purple and Payne's Gray. Lighten the soil's center with Khaki and horizontal back-and-forth strokes, using the ½-inch (12mm) synthetic comb. Randomly add Terra Cotta throughout the soil, in the same manner, with the uncleaned brush. Add Marbleized Cream using the same process. Wipe the excess paint from the ½-inch (12mm) synthetic comb, and apply streaks of Teal-reflected light in the outer areas. Dry thoroughly.

5 Paint the Skin's Shadows

Remove the design protectors, and wipe off any paint that may have seeped underneath them. Paint over the discolored spots with Whiteblend and dry before adding additional colors. Moisten the ½-inch (12mm) synthetic angle with Clearblend. Side load the angle with Burnt Sienna Wash on the long end, dissipating it back to the short end. Working only one area at a time with the angle brush, follow the shadow patterns on the grandmother's and little girl's skin. Soften any harsh lines with the tip of the comb, if needed. Dry completely. Use the same brush and technique to strengthen the darkest shadows by adding a speck of Dioxazine Purple to the Burnt Sienna Wash. Soften harsh lines with a clean comb brush moistened with Clearblend. Dry.

Removing Dried Paint

If needed, agitate stubborn buildup of dried paint with the tip of your palette knife to remove it.

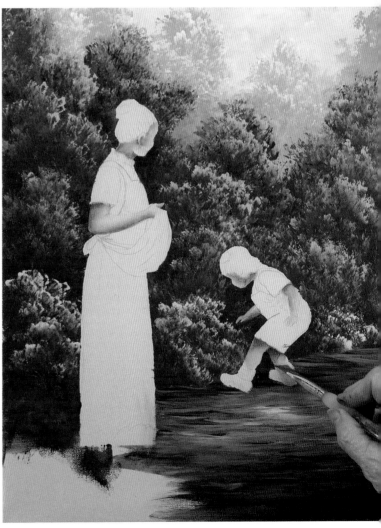

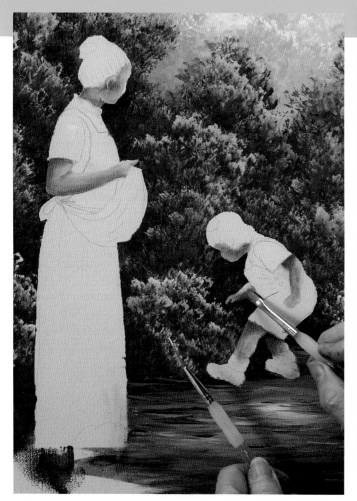

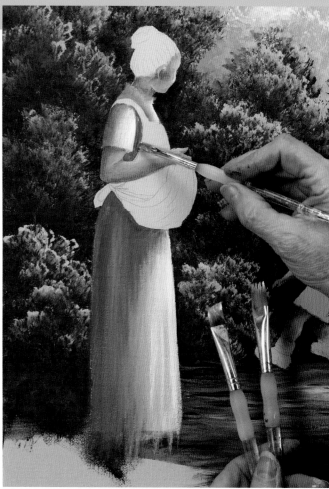

6 Highlight the Skin

Highlight and blend the skin wet-into-wet, working one part of the skin at a time. First, moisten the area with Clearblend, add the highlight then blend. Use the no. 4 synthetic flat to add Peach highlights to the grandmother's and granddaughter's forehead, cheek and chin, and blend with the tips of the ½-inch (12mm) synthetic comb. Add Marbelized Cream to the Peach on the uncleaned no. 4 synthetic flat, and highlight the top outer edge of the grandmother's cheek; blend toward the inside of her face with the ½-inch (12mm) synthetic comb. Omit the Marbelized Cream, and repeat this process for the grandmother's and granddaughter's arms and the granddaughter's legs. Dry thoroughly. Continue with the wet-on-wet technique, using random dashes of the Cadmium Red Light Glaze in some of the shadowy areas and blending toward the inside of their bodies. Moisten the grandmother's face again with Clearblend; add a touch of Pink (choose a value that can serve as a blusher) between her cheek and ear, and blend to soften the outer edges all around it. Once the skin is thoroughly dry, remoisten any area with Clearblend, and touch it up as necessary.

7 Paint the Grandmother's Dress

Work one area of her dress at a time. Use Denim for the dress's shadows, Sky Blue for the midtones and Off White for the brightest areas. Add interest to the fabric by brush mixing additional touches of Payne's Gray or Ultramarine Blue in the shadow and midtone areas. Add Whiteblend to the Sky Blue for the sunlight areas, with the brightest areas almost white. Apply the skirt colors with the ½-inch (12mm) synthetic angle, and blend the colors while wet with your clean ½-inch (12mm) synthetic comb. Paint the sash with Denim and the ½-inch (12mm) synthetic angle. Highlight the leading edge with Sky Blue on the no. 0 synthetic liner. Paint and blend the sleeve and the bodice of the dress in the same manner, using the no. 4 synthetic flat. Use the darkest value of Denim and the no. 0 synthetic liner to shade the inside of her sleeve. Soften the edge of the shadow where it touches her arm with the clean no. 4 synthetic flat moistened with Clearblend. Squiggle a lacy edge on the collar, and add a little bow on the front of the neck with the no. 0 synthetic liner, double loaded with a medium value of Denim on the bottom and Off White on the top. Dry.

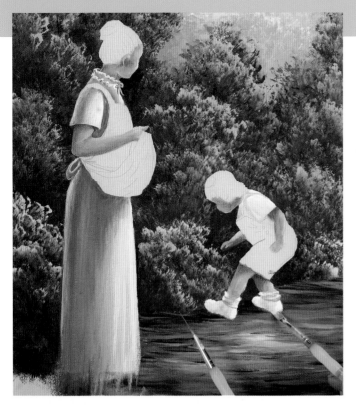

8 Finish the Dress, and Add the Child's Shirt, Shoes and Socks

Working one area at a time, moisten the back edge of the grandmother's bodice, sleeve, sash and skirt with Clearblend, using the ½-inch (12mm) synthetic angle. Add Light Cerulean-reflected light with the no. 0 synthetic liner, and blend with a clean ½-inch (12mm) synthetic comb.

Use a no. 4 synthetic flat and a very light value of Denim for the shadows on the child's shirt, shoes and socks. Highlight them with Off White and the ½-inch (12mm) synthetic angle. Keep the paint thin to let some of the basecoat show through.

9 Add the Grandmother's Apron

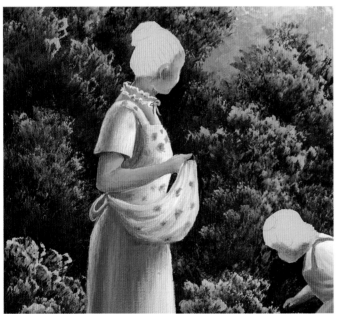

Apply the shadows of the apron with Purplish Violet, and highlight them with Off White. Use your ½-inch (12mm) synthetic angle, no. 4 synthetic flat, no. 0 synthetic liner and ½-inch (12mm) synthetic comb to apply and blend the colors according to what seems comfortable to you and appropriate for each area. Paint irregularly shaped flowers on the apron with the no. 0 synthetic liner and a coral color made by brush mixing Whiteblend and Cadmium Red Light. Darken this mixture with a touch of Burnt Umber, and dab in stamens in some of the larger flowers. Let this dry. Fade the flower print with the Clearblend/Whiteblend Wash and the no. 4 synthetic flat.

10 Add the Granddaughter's Coveralls

Paint the coveralls with the no. 4 synthetic flat and a brush mixture of Pink. Use a darker Pink in the shadows and a lighter Pink in the sunlight. Blend with the ½-inch (12mm) synthetic comb and dry. With the ½-inch (12mm) synthetic angle, moisten the coveralls with Clearblend. Strengthen the shadows with the no. 4 synthetic flat and a translucent glaze made of Clearblend and a speck of Acra Magenta. Add a speck of Payne's Gray to this and darken the shadows under her arm. Soften the outer edges, using the clean angle moistened with Clearblend. Add buttons with different values of Denim and Whiteblend on the no. 0 synthetic liner. Let the clothing dry; remoisten any area, and touch up as needed.

11 Paint the Grandmother's and Granddaughter's Hair

Use the ½-inch (12mm) wisp to streak the grandmother's hair with values of Denim, altering the value with White-blend. Allow touches of the basecoat to show through here and there. Wipe the brush clean, and highlight the foremost sunlit part of her hair with Whiteblend. Tidy up the edges with the no. 0 synthetic liner and the same colors. Add a Denim ribbon around the base of the bun with a clean no. 0 synthetic liner. Add a few Light Cerulean streaks of reflected light in her hair's shadowy areas with the no. 0 synthetic liner. Paint the base color of the granddaughter's hair a watery Burnt Sienna, and shade it with watery Burnt Umber streaks, using the ½-inch (12mm) wisp. Add highlights with the no. 0 synthetic liner and a brush mixture of Raw Sienna and Whiteblend for golden midtones. Brush mix light golden highlights, using Yellow Ochre, Cadmium Yellow Medium and Whiteblend. Let the hair dry. Add her bow with the colors you used for the coveralls and a no. 0 synthetic liner.

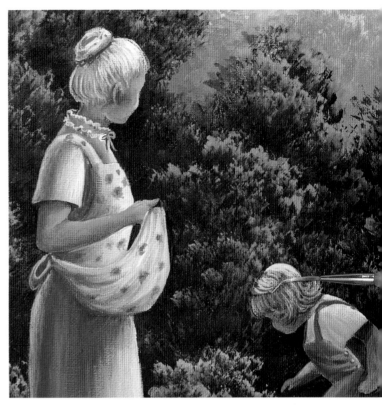

12 Add the Foremost Foliage and Flowers

Use Dark Green and the no. 2 bristle flat to tap a little foliage in front of the granddaughter's shoes. Soften the bottom with Clearblend loaded onto the clean ½-inch (12mm) synthetic comb. With the no. 12 bristle round loaded with Dark Green, tap and crunch lacy edges of foliage into the foreground. Load Teal on the top of the uncleaned no. 12 bristle round, and tap the reflected light randomly into the foliage. Load Yellow Green onto the top of the uncleaned no. 2 bristle flat, and crunch highlights on the top-right side of the foliage around the granddaughter's shoes. Dab a few leaves in the foreground shrub, using only the corner of the brush. Dry.

Tap small flowers on the shrubs behind the little girl using Marbleized Reddish Purple. Marbleize more Dioxazine Purple on the bottom of the brush, and add Acra Magenta with a touch more Whiteblend to the top. Crunch this mixture into larger flowers on the foreground shrub, reloading the brush frequently. Marbleize more Acra Magenta and a generous amount of Whiteblend on the top of the uncleaned brush, and highlight some blooms in the sunlit area of the foreground flowers. Add stems to some of the blooms with a clean no. 0 synthetic liner double loaded with Dark Green on one side and Yellow Green on the other.

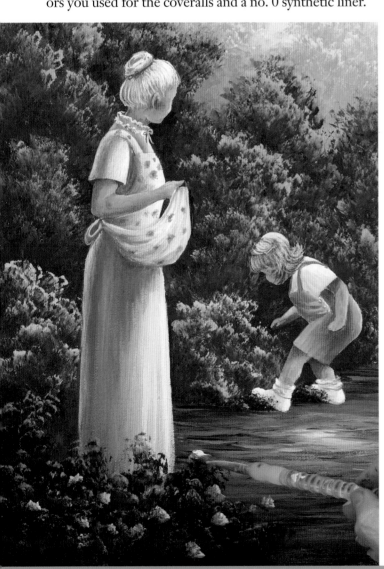

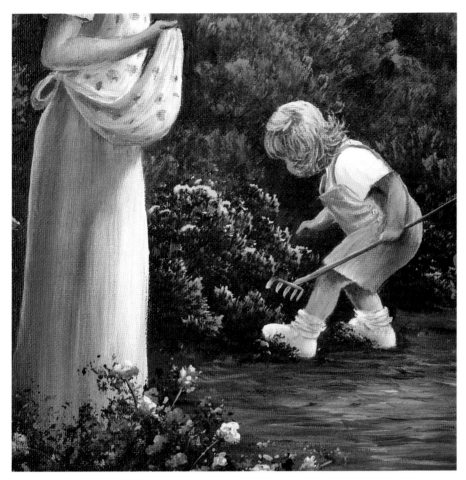

13 *Add the Rake*

Double load the no. 0 synthetic liner with a brush mixture of Burnt Umber, Payne's Gray and a touch of Whiteblend on the bottom and Peach on the top. Add the rake. Stop and start the rake handle on either side of the little girl's hand, making it appear that she is holding it.

14 *Paint the Birds*

Add birds flying into the garden with a clean no. 0 synthetic liner using your darkest value of Denim double loaded with Whiteblend. Sign and dry your painting. Spray it with an aerosol acrylic painting varnish to preserve the beauty of your masterpiece.

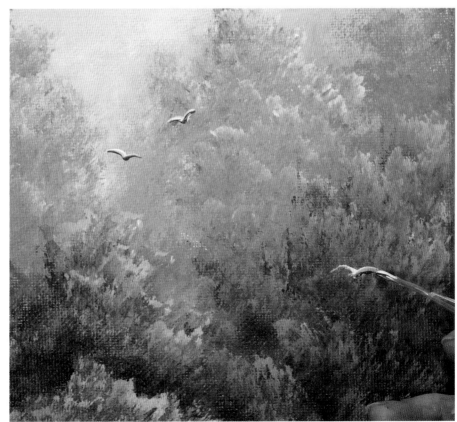

Bougainvillea Terrace

Flowers, flowers everywhere and not one in disarray! Neatly manicured vines creep up the walls and cascade off the rooftops and over the fences. Vibrant color bubbles over the rims of the buckets gracing the entryway, inviting us to come closer to see.

When I think of these images, my mind takes me to quaint villages in warm, inviting climates. I see visions of rustic charm created by generations of the past. Delightfully, many of the buildings have been preserved so we can enjoy the unique architecture today. Many of the structures house unforgettable restaurants in which accomplished chefs dazzle the hungry visitors with traditional dishes made with his or her own special flamboyance.

As an artist, I hope you will be like a gourmet chef, following the tried-and-true recipes (painting techniques) to ensure success, yet having the confidence to allow for your own "flair," which will be evident for all to enjoy.

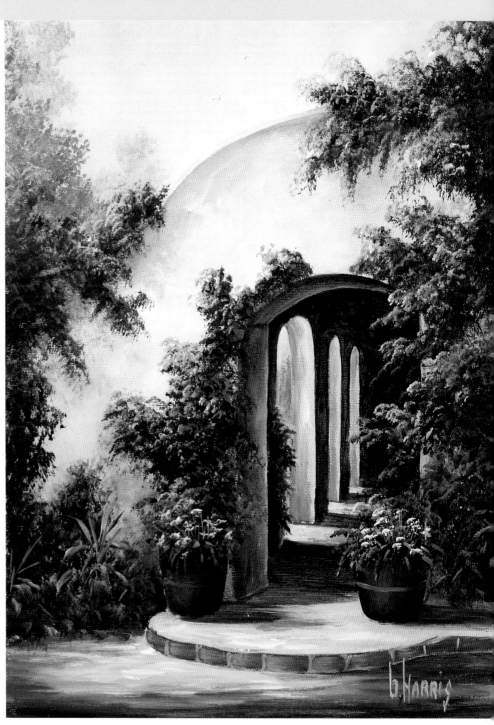

Bougainvillea Terrace
Acrylic on primed, stretched canvas
20" × 16" (51cm × 41cm)

Materials

Acrylic Colors
Acra Magenta, Burnt Sienna, Burnt Umber, Cadmium Red Medium, Cerulean Blue, Dioxazine Purple, Fleshtone Ceramcoat, Hooker's Green Deep, Payne's Gray, Raw Sienna, Titanium White, Ultramarine Blue, Vivid Lime Green, Yellow Ochre

Mediums
Clearblend, Slowblend, Whiteblend

Brushes
2-inch (51mm) bristle flat, nos. 2, 6 and 12 bristle flat, nos. 2 and 4 synthetic flat, no. 0 synthetic liner, no. 2 bristle filbert, no. 2 bristle fan, ½-inch (12mm) synthetic comb, ½-inch (12mm) mop, ½-inch (12mm) synthetic angle, palette knife

Pattern
Enlarge the pattern (page 104) 175 percent

Other
20" × 16" (51cm × 41cm) canvas, ½ tsp. of Slowblend per cup of water, aerosol acrylic painting varnish, charcoal graphite paper, little plastic cups (for the mediums), stylus, tape, two pieces of scrap paper

Color Mixtures

Before you begin, prepare these color mixtures on your palette:

Marbleized Sky Blue	10 parts Whiteblend + 1 part Ultramarine Blue + a touch of Cerulean Blue
Blue Violet Gray	6 parts Whiteblend + 1 part Ultramarine Blue + a speck of Dioxazine Purple + a speck of Payne's Gray
Medium Gray Green	2 parts Blue Violet Gray + 1 part Hooker's Green Deep + a touch of Whiteblend + a speck of Burnt Sienna
Dark Purple Brown	2 parts Burnt Umber + 1 part Dioxazine Purple + 1 part Ultramarine Blue
Light Violet Gray	(leave some of this mixture marbleized) 5 parts Blue Violet Gray + 5 parts Whiteblend + a speck Burnt Umber + a speck of Dioxazine Purple
Marbleized Turquoise	2 parts Cerulean Blue + 2 parts Whiteblend + 1 part Vivid Lime Green + 1 part Hooker's Green Deep
Off White	(leave some of this mixture marbleized) 25 parts Titanium White + a speck of Yellow Ochre
Peach	5 parts Whiteblend + a touch Cadmium Red Medium + a speck of Yellow Ochre
Terra Cotta	1 part Burnt Sienna + 1 part Cadmium Red Medium + a touch each of Yellow Ochre and Whiteblend
Variegated Deep Red	2 parts Cadmium Red Medium + a speck of Dioxazine Purple
Marbleized Hot Pink	2 parts Cadmium Red Medium + 2 parts Titanium White + 2 parts Whiteblend + 1 part Acra Magenta
Yellow Green	3 parts Vivid Lime Green + 3 parts Yellow Ochre + 1 part Hooker's Green Deep + 1 part Whiteblend
Cement	(make various values of this) Whiteblend + a speck of Dark Purple Brown
Dark Green	2 part Hooker's Green Deep + 1 part Burnt Umber + 1 part Burnt Sienna

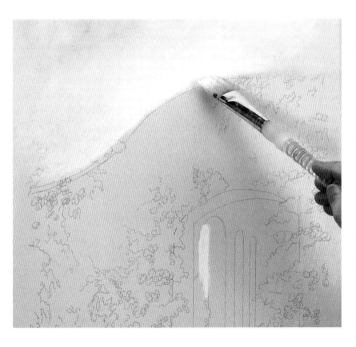

1 Prepare the Canvas, and Paint the Sky

Basecoat the canvas with Fleshtone Ceramcoat, using the 2-inch (51mm) bristle flat, and dry. Trace the pattern onto the canvas using the charcoal graphite paper and a stylus. Apply the sky using the no. 12 bristle flat. Use Marbleized Sky Blue at the top of the sky, adding Whiteblend to the uncleaned brush so the sky becomes almost white behind the building. Blend slightly with the ½-inch (12mm) mop. Add the sky showing through the foremost arch with the ½-inch (12mm) synthetic angle and a medium value of Marbleized Sky Blue.

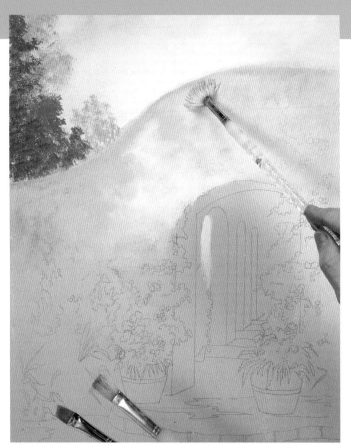

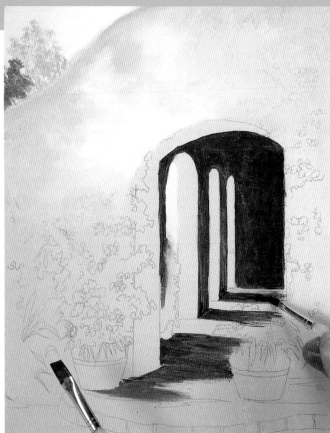

2 Stipple the Distant Trees and Paint the Building's Exterior

Brush mix Blue Violet Gray into the no. 2 bristle flat, and stipple the distant trees behind the building. Brush mix Medium Gray Green into the brush, and stipple the midground trees, leaving some of the background trees showing.

Moisten the front of the building with Clearblend using the no. 2 bristle fan. With the no. 6 bristle flat, accent parts of the building's front with marbelized Off White and Peach, applied intermittently, making the lightest area just above the left of the front door and allowing some of the basecoat to show through. Blend slightly with the ½-inch (12mm) mop. Leave the paint mottled, with areas of each color showing and some areas lighter in value. While this is wet, stipple the foliage's cast shadows on the building with the uncleaned no. 6 bristle flat and Light Violet Gray. Add a Light Violet Gray shadow along the building's top edge with the ½-inch (12mm) synthetic angle. Soften the bottom edges with the no. 2 bristle fan moistened with Clearblend. If any part of the building begins to dry at any point in this step, add more Clearblend to ensure soft blending and gradual transitions.

3 Paint the Building's Interior

Paint the interior shadows with the ½-inch (12mm) synthetic angle and Dark Purple Brown, varying the proportions of the components to add interest. Use the no. 2 synthetic flat for the small spaces between the arches. Reload your brush frequently, adding a touch of water to the paint so it spreads quickly and easily. Use erratic brushstrokes on the columns and walls and horizontal strokes for the floor's shadows. Paint the sunlit areas on the floor and stoop with Off White and the shadow areas Blue and Light Violet Gray and Dark Purple Brown.

Moisten the sides of the interior arches with Clearblend and the ½-inch (12mm) synthetic angle. Add Raw Sienna to the uncleaned ½-inch (12mm) synthetic angle and add random streaks over the arches and doorway. Darken some of the streaks with a touch of Burnt Sienna. Add a touch of Dark Purple Brown and more Clearblend to the brush, and apply this sparingly on the arches. Randomly add streaks of Off White in the lightest areas of the back three columns, on the floor and on the stoop with the no. 4 synthetic flat. Wipe clean the brush clean, and soften any areas that look disjointed, but leave some stuccolike texture and irregularity. Dry. If any areas need adjusting, cover the areas with Clearblend, and then blend the appropriate colors. Dry.

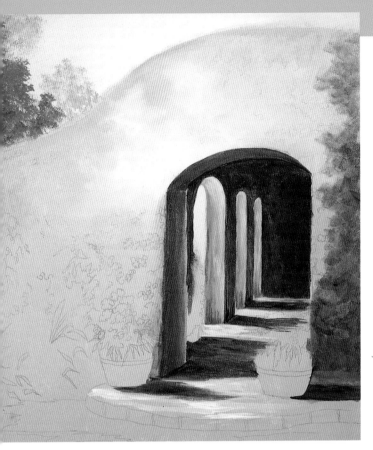

4 Add the Doorway and Exterior Shadows

Paint the front doorway slightly darker than the interior arches using the ½-inch (12mm) synthetic angle to create a deeper mixture of Clearblend, Raw Sienna and Burnt Sienna. Darken this mixture as needed by adding Dark Purple Brown. Leave the doorway more translucent than the building's interior. Dry. Moisten the arch with Clearblend, then streak a Blue Violet Gray and Light Violet Gray-reflected light onto the top of the arch with the ½-inch (12mm) synthetic angle. Soften with the no. 2 bristle flat. Moisten the right side of the exterior with Clearblend, then stipple and slip-slap a variegated Dark Purple Brown shadow on the right side of the building.

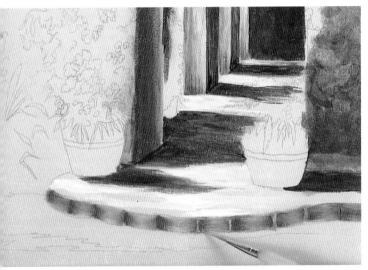

5 Add Tiles Around the Stoop

Moisten the tiles with the no. 2 bristle flat. Using the same brush, apply horizontal streaks of Terra Cotta on the tiles, starting at the mortar joints and stroking toward the center of each tile. Streak Off White highlights horizontally through the central area of the tiles with the ½-inch (12mm) synthetic comb, leaving a Terra Cotta shadow on each end of the tiles. Dry. Using a brush mixture of Clearblend and a touch of Dark Purple Brown, stroke outward from the mortar joints to create the crevices' shadows, stopping short of where the Terra Cotta shadow meets the highlight. Blend slightly with the corner of a clean ½-inch (12mm) synthetic comb. Draw the mortar seams with the no. 0 synthetic liner using various values of Cement, occasionally blotting the wet paint to subdue.

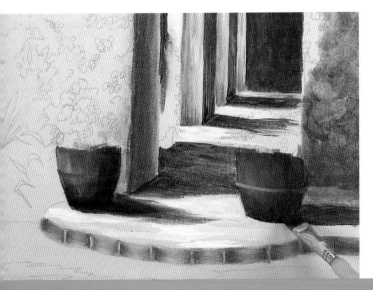

6 Paint the Flowerpots

Paint and blend the pots, one at a time. Use the ½-inch (12mm) synthetic angle and the no. 4 synthetic flat with the Dark Purple Brown on the shadow side of the flowerpots and Burnt Sienna on the sunlit side. Blend in the central area. While the paint is wet, add Terra Cotta accents in the pots' centers. Strengthen the highlight by adding Off White, and blend, allowing the highlight to dissipate into the shadows. Dry. Apply the band around the pots with the no. 0 synthetic liner and the Terra Cotta. Dry. Add shadows underneath the bands on the right with the liner and a watery Dark Purple Brown and Clearblend. Dry. Moisten the flowerpots with Clearblend, and touch up any shadows or highlights with the same brushes and colors.

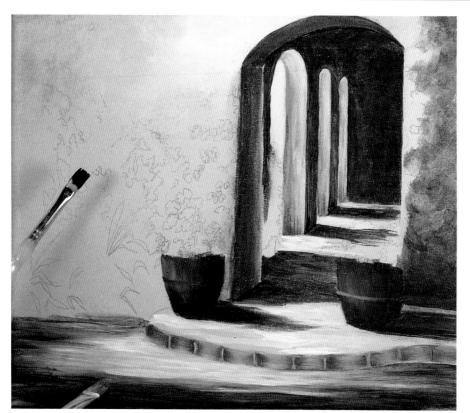

7 Add the Foregroound

Moisten the area with Clearblend, using a clean no. 2 bristle fan. Create shadowy areas on the ground with the Dark Purple Brown, using the no. 2 bristle flat. Vary the proportions of the mixture's components to make the color more interesting. Do not paint solidly, and allow some basecoat to show through. Add streaks of Off White in the sunlit areas with the ½-inch (12mm) synthetic comb. Wipe the excess paint from the brush, and use it to randomly add Marbleized Sky Blue and Light Violet Gray–reflected light. If all the base color is accidentally covered, add some of the base color, then slightly blend it with a clean ½-inch (12mm) synthetic comb.

9 Add the Foliage and Interior Pot

Move the paper to the entrance door and stipple the plant inside the pot in the building with the uncleaned no. 2 bristle flat and Dark Green. Double load the top of the uncleaned flat with Vivid Lime Green and a touch of Whiteblend and stipple highlighted edges on the right side of the bush. Add the pot beneath the foliage using the colors, brushes and techniques you used for the two pots on the building's exterior.

8 Add Distant Trees

Cover the arches with pieces of paper or tape, and stipple distant trees behind the building with the no. 2 bristle flat and Medium Gray Green.

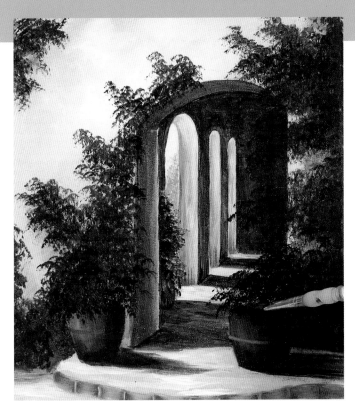

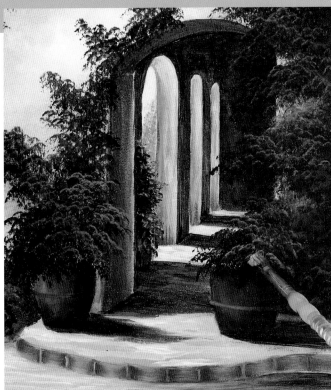

10 Stipple the Exterior Foliage

Use Dark Green to stipple the exterior foliage, alternating between the nos. 6 and no. 12 bristle flats to block in the large full areas of foliage. Switch to the no. 2 bristle filbert. Add the pots' foliage and the individual limbs and vines growing out along the foliage's edges. The vines should follow the architectural design of the building, meandering back and forth, with some vines overlapping the entryway and other parts of the building. Soften the bottom of the wet foliage with horizontal strokes and a ½-inch (12mm) synthetic comb moistened with Clearblend. Shield the pots and stoop with paper or tape when stippling the foliage behind them.

11 Add Reflected Light to the Foliage

Stipple reflected light in the foliage with the uncleaned no. 2 bristle filbert, double loaded with Dark Green on the bottom and Marbleized Turquoise on the top. Lightly tap this back and forth throughout the foreground vines and foliage.

12 Highlight the Foilage

Brush mix Vivid Lime Green, Yellow Ochre and a touch of Whiteblend onto the Marbleized Turquoise side of the uncleaned no. 2 bristle filbert, and lightly stipple highlights along the light parts of the foliage, leaving it darker on the shadows.

13 Add Final Highlights

Add Off White to the top of the uncleaned no. 2 bristle filbert. Stipple the final highlight into the sunlit areas. Do not put this highlight on all the foliage, but only in the places that appear to be in direct sunlight.

14 Add Bougainvillea Blooms

Use the no. 2 bristle flat to stipple Varigated Deep Red clusters throughout the vines. Rinse the brush, and add a generous amount of Marbleized Hot Pink. Use this for the sunlit bougainvillea blooms, ranging from almost pure red to almost pure white. Reload the brush frequently and generously so the paint comes off easily and the dabbles remain thick on the canvas.

15 Add the Potted Flowers

Draw some stems in the pots using the no. 0 synthetic liner and a watery Yellow Green. Double load the no. 4 synthetic flat with Yellow Ochre on the bottom and Off White on the top. Add the flowers randomly on top and within the stems. Add a touch of Titanium White to the top of the no. 4 synthetic flat for the most sunlit blooms. Add Yellow Green to the uncleaned no. 0 synthetic liner and add leaves around the left side of the plants. Add a Marbleized Turquoise on the right side of the plants.

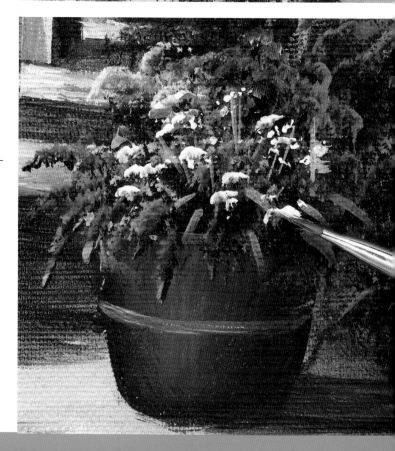

16 Add Leafy Plants

Double load the no. 0 synthetic liner with Dark Green on one side of the liner and marbleized Vivid Lime Green, Yellow Ochre and White-blend on the other. Draw in the leaves in for the plants along the edge of the building, holding the brush so that Dark Green is applied to the bottom or right side of the leaves and stems. With a clean no. 0 synthetic liner, add some leaves with Marble-ized Turquoise on the right of each cluster of the plants.

17 Add the Birds

Double load your no. 0 synthetic liner with Blue Violet Gray and Light Violet Gray on the bottom and Whiteblend on the top. Add a few birds flying into the scene. Sign and dry your painting, then spray it with an aerosol acrylic painting varnish. Enjoy your "Bougainvillea Terrace" in bloom all year long!

Vine Ripened

Get your basket, and to market we will go! We find in this garden market a plethora of our favorite things waiting to be gathered for today's table—all more fragrant, colorful, riper, juicier and tastier than we can ever imagine. A bonus to the wonderful taste and smell, inside of each plant lie the seeds to a new generation.

By breaking this painting down into a step-by-step format, I have tilled the soil, planted the seeds and nurtured the growth of these techniques. Now it is up to you to harvest them. Get your brushes moving! With a positive attitude and a little practice, your artistic skills and talents will grow and multiply. Enjoy the exhilarating feast, but don't discard the seeds! When you take what you learn from here and share it with others, you will be planting the seeds for new generations of artists. I hope you will do that. When you teach others, you will be rewarded immensely; you, too, will become "Vine Ripened."

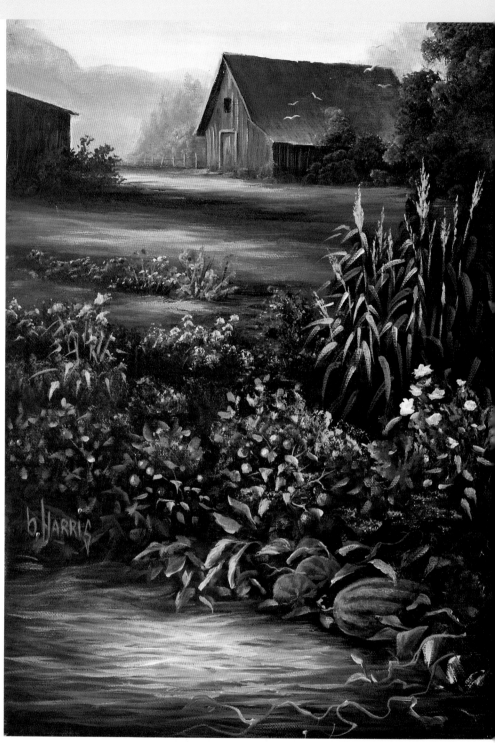

Vine Ripened
Acrylic on primed, stretched canvas
16" × 12" (41cm × 30cm)

Materials

Acrylic Colors
Burnt Sienna, Burnt Umber, Cadmium Red Light, Cadmium Red Medium, Cadmium Yellow Medium, Cerulean Blue, Dioxazine Purple, Hooker's Green Deep, Payne's Gray, Raw Sienna, Ultramarine Blue, Vivid Lime Green, Yellow Ochre

Mediums
Clearblend, Slowblend, Whiteblend

Brushes
Nos. 2, 6 and 12 bristle flat, no. 4 synthetic flat, no. 2 synthetic round, no. 0 synthetic liner, ½-inch (12mm) synthetic comb, ½-inch (12mm) synthetic angle, ¾-inch (19mm) mop, palette knife

Pattern
Enlarge the pattern (page 105) 175 percent

Other
16" × 12" (41cm × 30cm) canvas, ½ tsp. of Slowblend per cup of water, aerosol acrylic painting varnish, charcoal and white graphite paper, little plastic cups (for the mediums), scrap paper, stylus, tape

Color Mixtures

Before you begin, prepare these color mixtures on your palette:

Sky Blue	10 parts Whiteblend + 1 part Ultramarine Blue
Violet Gray	25 parts Whiteblend + 2 parts Payne's Gray + 1 part Dioxazine Purple
Pink	10 parts Whiteblend + 1 part Cadmium Red Medium (vary the parts to get lighter or darker values)
Mocha	4 parts Burnt Sienna + 4 parts Whiteblend + 1 part Payne's Gray
Dark Brown	2 parts Payne's Gray + 1 part Burnt Sienna + a speck of Whiteblend
Dark Green	1 part Hooker's Green Deep + 1 part Burnt Sienna + 1 part Payne's Gray
Medium Green	3 parts Dark Green + a touch of Whiteblend
Light Green	1 part Dark Green + 1 part Whiteblend
Medium Yellow Green	2 parts Vivid Lime Green + 1 part Medium Green + 1 part Whiteblend
Bright Yellow Green	5 parts Vivid Lime Green + 4 parts Whiteblend + 1 part Yellow Ochre
Light Yellow	6 parts Whiteblend + 1 part Yellow Ochre
Bright Yellow	6 parts Whiteblend + 1 part Cadmium Yellow Medium
Turquoise	2 parts Dark Green + 2 parts Cerulean Blue + 1 part Whiteblend
Wheat	2 parts Whiteblend + 1 Raw Sienna
Tan	1 part Light Yellow + 1 part Mocha
Marbelized Deep Blue	1 part Ultramarine Blue + a touch of Whiteblend

1 Prepare the Canvas, and Paint the Sky, Distant Hills and Trees

Trace the design onto the canvas with charcoal graphite paper and a stylus. Paint the sky with the no. 6 bristle flat and Sky Blue. Apply the color in streaks across the top of the sky, gradually adding more Whiteblend so the sky is lightest where it tucks down behind the mountains. Blend unwanted brush marks using horizontal strokes with a ¾-inch (19mm) mop. Add the mountains with varying values of Violet Gray using the ½-inch (12mm) synthetic angle. Make the farthest mountain lighter than those closer. Lighten the base of the mountains with more Whiteblend, and blend with the ¾-inch (19mm) mop. Protect the edge of the barn with a piece of paper or tape, and stipple trees behind the building using Violet Gray and the no. 2 bristle flat. Stipple Light Green trees behind the barn on their right with the uncleaned no. 2 bristle flat. Add Light Yellow to the top of the uncleaned brush, and tap highlight onto the top-left edges of the Light Green trees.

2 Paint the Barns

Paint the darkest barn with the ½-inch (12mm) synthetic angle and Dark Brown. Add vertical streaks with Violet Gray and the tips of the ½-inch (12mm) synthetic comb. Paint the eaves and shadow side of the barn with the ½-inch (12mm) synthetic angle and Dark Brown. Add woodgrain on the side with the ½-inch (12mm) synthetic comb and Violet Gray.

Paint the lighter barn's roof using the ½-inch (12mm) synthetic angle with Dark Brown and a touch of Mocha, leaving the values variegated. Turn the canvas upside down. Using the uncleaned angle brush, add Sky Blue streaks to the roof's bottom. Start each stroke at the roof's bottom and move toward the top. Blend slightly with the ¾-inch (19mm) mop. Paint the barn's front

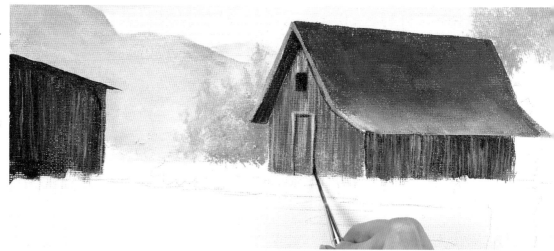

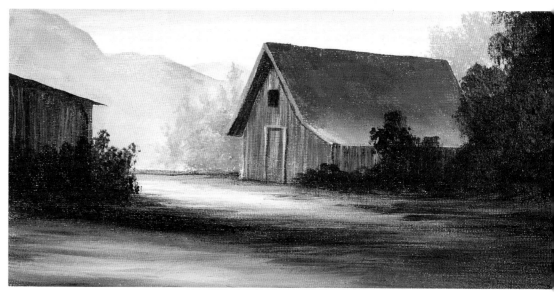

Mocha with a clean ½-inch (12mm) synthetic angle. Add vertical streaks with the ½-inch (12mm) synthetic comb and Wheat. With the no. 0 synthetic liner, add a Wheat edge along the roofline and around the barn door. Darken the hayloft, and add shadows to the door's moldings using the clean no. 0 synthetic liner and a watery Dark Brown.

3 Paint the Trees in Front of the Barns and Distant Barnyard

Stipple midground foliage on the shadow side using Dark Green and the no. 2 bristle flat. Reload the brush frequently, adding a touch of water each time. Anchor the base of the foliage to the ground, and establish the barnyard shadows with a ½-inch (12mm) synthetic comb moistened with Clearblend. Make horizontal strokes along the bottom edge of the foliage, and add more Dark

Green to the comb if necessary. Use a clean no. 2 bristle flat to stroke Light Yellow horizontally between the buildings. Establish a gradual transition between light, medium and dark areas by alternating with Dark Green with the ½-inch (12mm) synthetic comb and Light Yellow with the no. 2 bristle flat. Stipple the tree in front the barn on the left with the no. 2 bristle flat and Dark Green. Stroke a Dark Green shadow across the barnyard. Continue adding to the barnyard, alternating between the Dark Green on the ½-inch (12mm) synthetic comb and Light Yellow on the no. 2 bristle flat. Occasionally add a dash of Vivid Lime Green and blend. Dry.

4 Add the Flower Bushes

Double load a no. 0 synthetic liner with watery Burnt Umber on the right and Light Yellow on the left. Add the fence. Make the posts taller and farther apart nearest the barn, gradually becoming shorter and closer together as they recede in the distance. Stipple flower bushes in the shadowy area below the foremost light streak in the barnyard with the uncleaned no. 2 bristle flat and Dark Green. Double load the uncleaned no. 2 bristle flat with Turquoise on the top. Crunch reflected light onto leading edges of the foliage clusters of the Dark Green trees and flower bushes. Double load Bright Yellow Green onto the Turquoise side of the uncleaned no. 2 bristle flat and highlight the tree in front of the barn on the right and the flower bushes. Dry. Using the ½-inch (12mm) synthetic comb, moisten the ground underneath the flower bushes with Clearblend. With the comb, slip-slap dashes of Burnt Umber alternately with Burnt Sienna across the wet Clearblend. Add Wheat to the top of the uncleaned comb, and slip-slap short horizontal dashes of sunlight into the wet area. Dry.

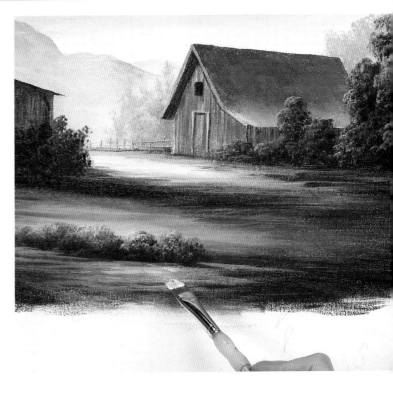

5 Establish the Garden Foliage and Foreground

Stipple the garden's foreground foliage with the no. 12 bristle flat using Dark Green, reloading the brush frequently. Moisten the canvas below the foliage with Clearblend on the no. 2 bristle fan. Anchor the foliage into the wet Clearblend with horizontal strokes and a bit more Dark Green. Apply and blend the ground's colors into the wet Clearblend with the ½-inch (12mm) synthetic comb, held horizontally and using short, horizontal stokes. Apply the darkest colors on the outer portions of the ground, adding lighter colors toward the center and blending the edges of each color into the next. Start with Burnt Umber for the bottom of the foliage and in the outer areas of the foreground, then lighten it with Burnt Sienna. Into these colors, add a few dashes of, Dioxazine Purple, Payne's Gray and Cadmium Red Medium. Continue inward with Mocha, Tan, Pink and Light Yellow. Before the ground dries; add random dashes of reflected light in the shadowy areas using Violet Gray, Sky Blue and Turquoise. Stroke these colors back and forth to create a gradual transition between the colors and values. Add Clearblend or water to your brush, if necessary, to keep the paint workable. Should the paint start to dry, stop and dry the area. Remoisten the area with Clearblend, then continue adding and blending colors. Dry.

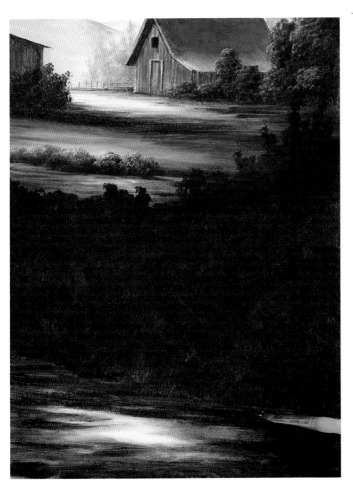

6 Add the Cornstalks

Trace the pattern of the garden plants and vegetables using white graphite paper and a stylus. As you paint the garden foliage, leaves and vegetables, reload your brushes frequently, adding a touch of water to your paint each time and do not wash the brush between colors. Draw the cornstalks with the no. 0 synthetic liner using Medium and Light Green. Intermittently streak Medium Yellow Green highlights on some of the cornstalks. Add long, tapering leaves on and around the center and left sides of the cornstalks using Medium Green, Light Green, Medium Yellow Green and Bright Yellow Green. Add Turquoise leaves on the right of the corn stalks and corn patch. Tap both Light Yellow and Bright Yellow Green tassels on the tops of the cornstalks with the ½-inch (12mm) synthetic comb, turned vertically. Tap some tassles straight up and down and have others fan outward. Add a couple of dabbles of Wheat on a few of the taller tassles.

7 Add the Tomatoes

Block in green tomatoes in a variety of sizes with thinned Vivid Lime Green and the no. 0 synthetic liner. Add a touch of Whiteblend to highlight the tomatoes' left sides. Wipe the excess paint from the liner, and blend the color slightly. Add a Light Yellow catchlight dot in the top-left area of the green tomatoes. Paint the red tomatoes in the same manner with Cadmium Red Light. Add a touch of Cadmium Yellow Medium and Whiteblend to the mixture for the highlight on the left side of the red tomatoes. Add their catchlight on the top-left side with Bright Yellow. For variety, occasionally add some of the green tomato colors to the red ones, and add some of the red tomato colors to the green ones to create half-ripened tomatoes in your patch. Draw a few twigs on some tomatoes, using your no. 0 synthetic liner double loaded with Medium Green and Bright Yellow Green. Add the leaves in and around the tomatoes, using the no. 0 synthetic liner for the small leaves and the no. 2 synthetic round for the larger ones.

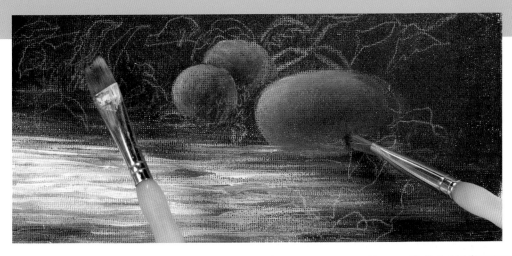

8 Add the Melons

Paint one melon at a time, working wet-into-wet. Moisten a melon with Clearblend using the ½-inch (12mm) synthetic comb. Side load the ½-inch (12mm) angle and define the melon's outer edge to apply the melon's colors along the edge and blend toward the inside with the ½-inch (12mm) synthetic comb moistened with Clearblend. Leave some portions of the bottom and right side of the melon unpainted and obscured by the foliage's shadows. Define the melon's shadow side with Turquoise and blend toward the inside with the ½-inch (12mm) synthetic comb. Define the top of the melon with Bright Yellow Green along the most sunlit edge, Medium Yellow Green in the medium light area, and Turquoise where the melon's top merges into shadow, blending toward the inside. Repeat for all melons and dry.

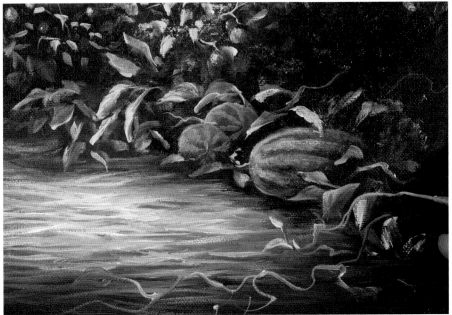

9 Add the Melons' Stripes and Leaves

Remoisten the melons with Clearblend one at a time. Make the stripes narrower at the ends and gradually wider in the center of each melon. Apply, then blend one squiggly, uneven stripe at a time, using the no. 0 synthetic liner to apply the paint and the ½-inch (12mm) synthetic comb to blend. Use Bright Yellow Green in the most sunlit spots on the stripes, Medium Yellow Green in the half-lit areas, and Turquoise in the shadowy areas. Dabble to blend the outside edges of the stripes, the areas where one color merges into another, and where the Turquoise stripes blend and disappear into the shadows. Add more Clearblend to the brush as you blend, if necessary. Repeat this for all the stripes on each melon. Should you lose all or too much of the Dark Green, add, then blend some of this color back in. Add large leaves, turning in different directions around the melons using the no. 2 synthetic round double loaded with any color of green or combination of green colors from your painting. Add curly vines and tendrils meandering around the ground and melons using the same leaf colors, double loaded on your no. 0 synthetic liner, adding a bit more water to the liner brush colors so that the paint glides easily.

Spice It Up

Variety adds spice to life, so choose the mixtures of greens you want for the melons' leaves.

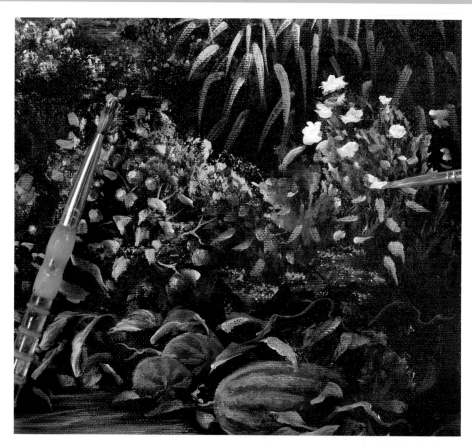

10 *Add the Blue Asters*

Brush mix a Marbleized Deep Blue, and tap aster blooms in a variety of shapes and sizes on top of the filler foliage to the right of the tomatoes using the no. 4 synthetic flat. Add more Whiteblend, but keep the mixture marbleized, into the top of the uncleaned brush, and highlight some of the more prominent asters.

11 *Add Additional Foliage*

Tie the garden together with filler leaves and flowers. Stipple and crunch filler speckles, and stroke leaves randomly throughout the garden, filling in voids and creating foliage for various flower bushes. Use the no. 12 bristle flat double loaded with Dark Green on the bottom and various values of previously used Bright Yellow Green and Bright Yellow Green on the top.

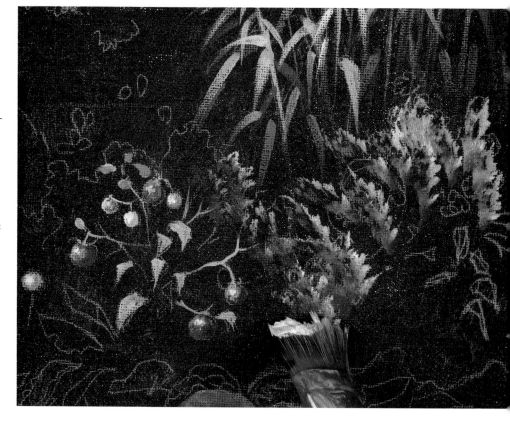

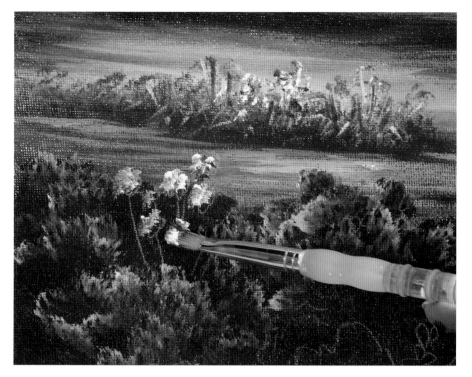

12 Add the Distant Flowers

Apply the most distant flowers, using a variety of your favorite colors. Experiment, mixing anything from your palette. Lightly tap and crunch tiny dabbles of your flower colors in and around the green patch just behind the distant patch of earth and in the rear of the garden, using only the corner of the no. 2 bristle flat. Use more paint and a larger portion of the brush to add the larger flowers in the rear of the garden. Add highlights to your flowers by double loading and marbleizing Whiteblend into your flower colors. Load this into the top of the uncleaned no. 2 bristle flat, and tap the highlight sparingly on the flowers. Add stems and leaves, using various values of any or all the greens used to create the garden. Use the no. 0 synthetic liner for small stems and leaves and the no. 2 synthetic round for the larger leaves.

13 Add the Birds

Add the birds, using the no. 0 synthetic liner double loaded with Violet Gray on the bottom and Whiteblend on the top. Sign your painting and dry it. Spray your "Vine Ripened" garden with an aerosol acrylic painting varnish to preserve your work.

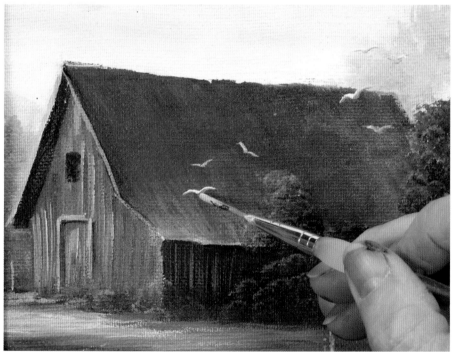

Creating the Middle Ground Yellow Flowers

Step 12 is the time to show your creativity by creating your own flower colors. However, if you want to know how I created the yellow flowers in the midground, just double load Yellow Ochre in the bottom of the no. 2 bristle flat and Cadmium Yellow Medium and Whiteblend in the top, then randomly dabble them on.

Spring Flowers

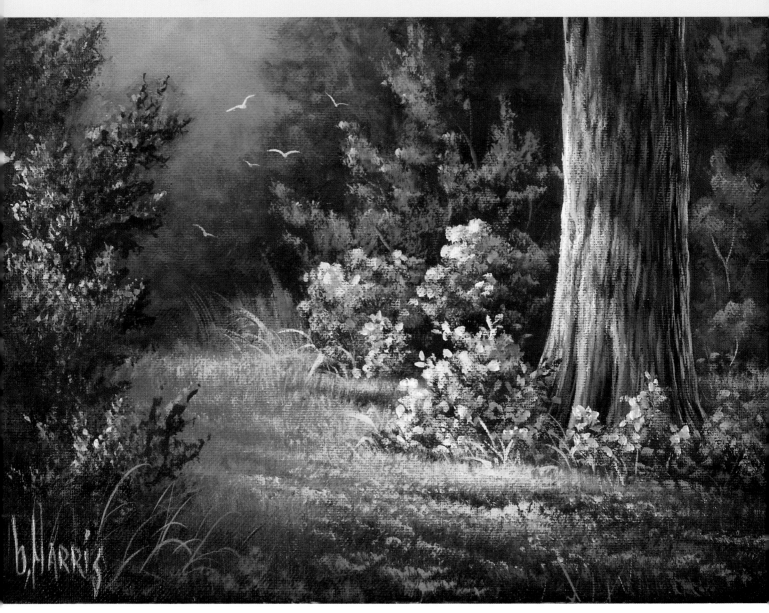

There is nothing more exhilarating to an artist than a walk in the countryside, experiencing the tantalizing tweaks to our senses, seeing the many various colors of plants, breathing the fragile aromas floating about, feeling the warmth of sunlight and the coolness of the shadows, hearing the sounds of nature and tasting the freshness of the breeze. So walk with me through these techniques to fill your canvas with glorious "Spring Flowers."

Spring Flowers
Acrylic on primed, stretched canvas
11" × 14" (28cm × 36cm)

Materials

Acrylic Colors
Burnt Sienna, Burnt Umber, Cadmium Red Light, Cadmium Red Medium, Cadmium Yellow Medium, Hooker's Green Deep, Payne's Gray, Titanium White, Ultramarine Blue, Vivid Lime Green, Yellow Ochre

Mediums
Clearblend, Slowblend, Whiteblend

Brushes
Nos. 2, 6 and 12 bristle flats, no. 4 synthetic flat, no. 0 synthetic liner, no. 2 bristle fan, no.10 bristle angle, ¾-inch (19mm) mop, ½-inch (12mm) synthetic comb, palette knife

Pattern
Enlarge the pattern (page 106) 167 percent

Other
11" × 14" (28cm × 36cm) canvas, ½ tsp. of Slowblend per cup of water, aerosol acrylic painting varnish, charcoal graphite paper, little plastic cups (for the mediums), stylus

Color Mixtures

Before you begin, prepare these color mixtures on your palette:

Light Pink	15 parts Whiteblend + 1 part Cadmium Red Medium
Pinkish Violet	30 parts Whiteblend + 4 parts Ultramarine Blue + 1 part Cadmium Red Medium
Blue Violet	1 part Pinkish Violet + 1 part Ultramarine Blue
Medium Green	2 parts Ultramarine Blue + 1 part Cadmium Yellow Medium + 1 part Vivid Lime Green
Yellow Green	4 parts Cadmium Yellow Medium + 1 part Medium Green
Light Yellow Green	1 part Yellow Green + 1 part Cadmium Yellow Medium + 1 part Whiteblend
Dark Green	1 part Hooker's Green Deep + 1 part Burnt Umber + 1 part Burnt Sienna + 1 part Payne's Gray
Medium Blue Green	1 part Blue Violet + 1 part Medium Green
Cream	25 parts Whiteblend + a speck of Yellow Ochre
Coral	1 part Cadmium Red Medium + 1 part Burnt Sienna + 1 part Whiteblend
Terra Cotta	2 parts Cadmium Red Medium + 2 parts Whiteblend + 1 part Coral

1 Paint the Sky and Background

Trace the canvas with charcoal graphite paper and a stylus. Use the no. 10 bristle angle to paint Light Pink in the top of the sky. With the uncleaned brush, slip-slap Pinkish Violet over the Light Pink, letting some of the Light Pink show through. Work back and forth between the colors throughout the sky, making the pink dissipate as you move toward the horizon. Add Blue Violet to the uncleaned brush. In the same fashion, alternate between the Pinkish Violet and Blue Violet so the Pinkish Violet dissipates as you approach the meadow line. Blend slightly with the ¾-inch (19mm) mop. Add Blue Green to the uncleaned no. 10 bristle angle. Hold the angle vertically and tap, back and forth, to create distant trees overlapping the sky. With the ¾-inch (19mm) mop, soften the edges where the sky and treetops merge. Gradually darken the foreground trees by adding more Medium Green as you proceed downward. Anchor the foliage and create ground shadows by moistening the ½-inch (12mm) synthetic comb with Clearblend and horizontally stroking this along the foliage's base. Add more Medium Green if needed.

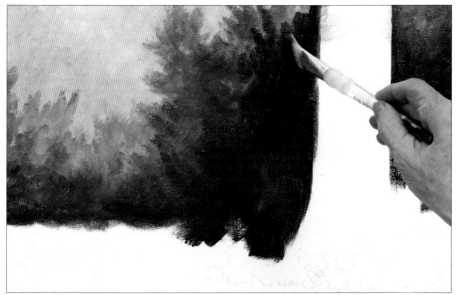

2 Add the Foliage

Add Medium Blue Green to the top, left side of the uncleaned no. 10 bristle angle. Tap and shift the brush from side to side to create random clusters of reflected light on limbs in the dark foliage. Side load the top, right side of the uncleaned brush with Yellow Green and stipple sunlit tree shapes in the foliage by shifting the brush from side to side. Add Light Yellow Green to the tip of the uncleaned brush and tap highlights on a few limb tips.

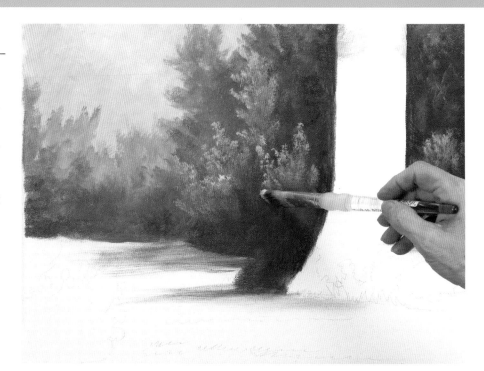

3 Add the Tree Trunk

Paint the tree trunk Burnt Umber with the ½-inch (12mm) synthetic comb, reloading frequently, and adding a touch of water so paint spreads well. Using the uncleaned ½-inch (12mm) synthetic comb, add intermittent strokes of Payne's Gray on the shadow side of the tree, dissipating the color short of the center. Load the left side of the brush with Coral and add a few intermittent strokes to indicate bark through the tree's center and light side. Load the Coral side of the brush with Light Pink and add choppy pink strokes that unevenly dissipate in streaks ending about three-fourths of the way around the tree. Add Cream to

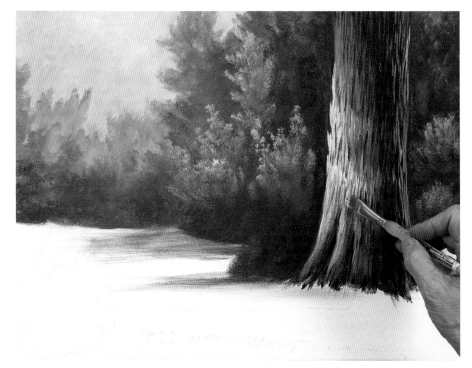

the Light Pink side of the brush and add choppy strokes in the most sunlit area of the tree, ending short of where the Light Pink strokes end. With a clean brush ½-inch (12mm) synthetic comb loaded with Burnt Umber on the left side and Blue Violet on the right, add choppy strokes to the shadow side of the tree. Wipe the Blue Violet from the brush and add a few strokes of Pinkish Violet slightly inward, but not extending past the center of the tree. Dry. Moisten the tree with Clearblend and touch up any colors as needed.

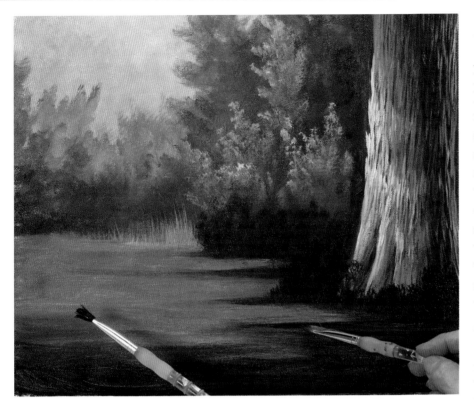

4 Add the Base for the Flowers and Grass

Load your no. 6 bristle flat with Dark Green, and stipple the flowers' foliage at the tree's base. With the same brush, make horizontal strokes at the bottom of the foliage to drag shadows across the grass. Lift some tall grass up and over the base of the distant trees with the ½-inch (12mm) synthetic comb and a watery Medium Green. Block in the light area of the garden with the no. 2 bristle fan and a creamy Medium Green mixture, stroking and crunching as you go. In the same manner, add Dark Green in the shadowy areas of the grass with the uncleaned brush, overlapping and blending the colors to create a gradual transition of medium to dark as you paint.

5 Add the Flowers

Brush mix the flowers' marbleized colors. Tap and stipple lightly with the no. 2 bristle flat to paint the blooms. Use various values of Ultramarine Blue and Whiteblend for the variegated blue blooms. Add Light Pink to the uncleaned brush for random blooms around these areas. Clean the brush and add variegated yellow flowers with values of marbleized Whiteblend and Yellow Ochre. Double load Cadmium Yellow Medium and Whiteblend to the top of the uncleaned brush and add brighter, almost white blooms to the top left side of the bush. Add a touch of Cadmium Red Light to the yellow in the uncleaned brush to create a peach. Dabble accents of peach in the variegated yellow bush. Clean

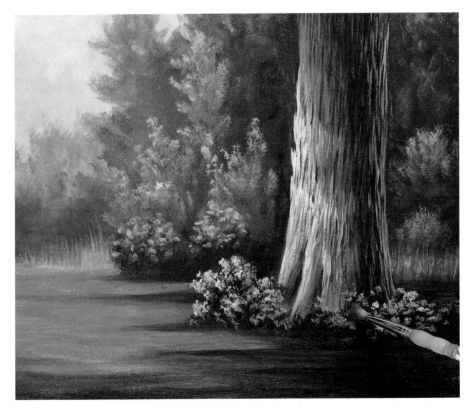

the brush, mix a variegated hot pink using Whiteblend and Cadmium Red Medium and add the blooms. Add more Whiteblend to the uncleaned brush to create highlighted blooms in and around the hot pink ones.

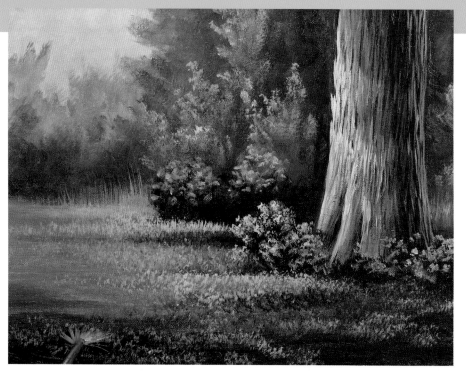

6 Add Details to the Grass

Add the grass highlight and reflected light wet-into-wet. First, use the no. 12 bristle flat to moisten the grass with Clearblend. Then, with the no. 2 bristle fan loaded with Yellow Green, alternate crunching and lifting to create leafy grass in the sunlit areas along the bottom. Mix Dark Green into the uncleaned fan, and stipple the grass texture where the shadow begins to create a value transition. Double load a clean no. 2 bristle fan with Dark Green on the bottom and Blue Violet on the top (alternate occasionally with Pinkish Violet). Crunch reflected light texture in the shadowy areas of the foreground grass. If the highlighted or reflected light areas seem to float, blot their bottoms while wet or tap their bottoms with a no. 2 bristle fan loaded with thinned Dark Green to anchor them.

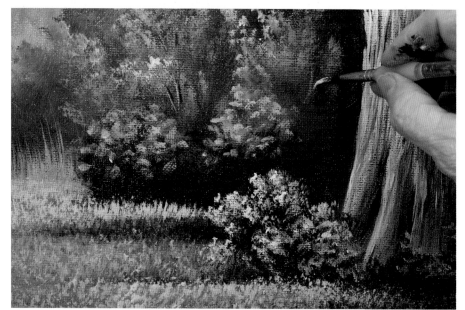

7 Add the Twigs in the Background Foliage

Double load your no. 0 synthetic liner with Burnt Umber and Light Pink. Add the twigs in the background foliage. Blot the bottom of the wet twigs to recede them into the shadow.

8 Add Detail Border Grass

With the no. 0 synthetic liner and thinned paint, add a few detail blades of grass in and around the shrubs, using various values of Medium Green and Light Yellow Green.

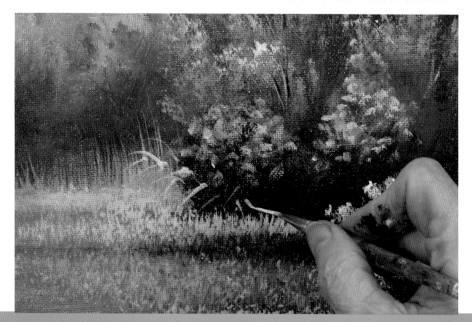

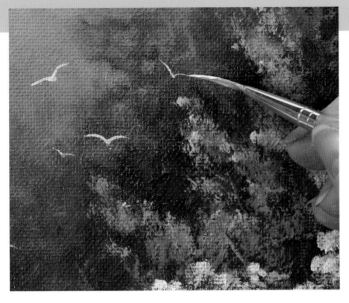

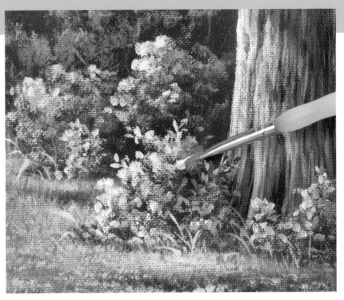

9 Add the Birds

Draw in the birds flying over the distant foliage with the no. 0 synthetic liner and a brush mixture of Whiteblend, Blue Violet and water.

10 Add the Flowers' Detail Around the Tree

With the no. 4 synthetic flat, dabble additional highlights to the tops and left sides of all the flowering shrubs, using each flower's color lightened with a touch of Titanium White, respectively.

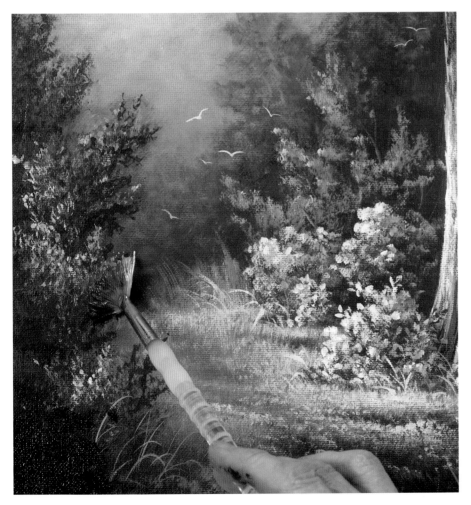

11 Add the Foreground Shrub

Crunch in the foreground tree using the no. 2 bristle fan loaded with Dark Green. Hold the brush vertically, then crunch from side to side to create the limbs for the tree. Crunch leaves on the top-left side of the green limbs with Coral. Add Terra Cotta to the top of the uncleaned fan and sparingly dabble a few lighter leaves on the top portion of the Coral leaves. Sign your painting. When it is thoroughly dry, spray it with an aerosol acrylic painting varnish. Sit back, and imagine the fragrance of your spring garden.

Double Trouble

It takes only a moment to know that the serenity of this vista will be short lived. These innocent young goslings are notoriously known for causing paths of destruction, and by the gleam in their eyes, today will be no different. So get your brushes ready, and let's capture this fleeting moment!

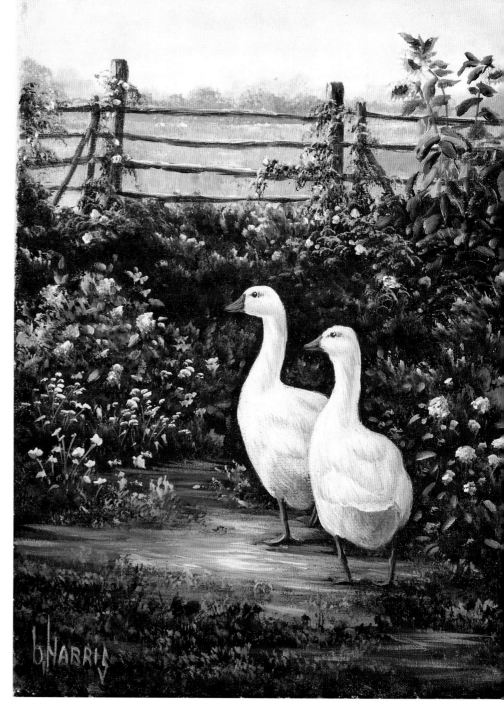

Double Trouble
Acrylic on primed, stretched canvas
16" × 12" (41cm × 30cm)

Materials

Acrylic Colors
Burnt Sienna, Burnt Umber, Cadmium Red Light, Cadmium Red Medium, Cadmium Yellow Medium, Cerulean Blue, Dioxazine Purple, Hooker's Green Deep, Payne's Gray, Raw Sienna, Ultramarine Blue, Vivid Lime Green, Yellow Ochre

Mediums
Clearblend, Slowblend, Whiteblend

Brushes
Nos. 2, 6 and 12 bristle flat, nos. 2 and 4 synthetic flat, no. 2 synthetic round, no. 12 bristle round, no. 0 synthetic liner, no. 2 bristle fan, no. 2 bristle filbert, ½-inch (12mm) synthetic comb, ½-inch (12mm) mop, ½-inch (12mm) wisp, ½-inch (12mm) synthetic angle, palette knife

Pattern
Enlarge the pattern (page 107) 159 percent

Other
16" × 12" (41cm × 30cm) stetched canvas, ½ tsp. of Slowblend per cup of water, adhesive-backed paper, aerosol acrylic painting varnish, charcoal and white graphite paper, kneaded eraser, little plastic plastic cups (for the mediums), scissors, stylus

Color Mixtures

Before you begin, prepare these color mixtures on your palette:

Sky Blue	10 parts Whiteblend + 1 part Ultramarine Blue
Peach	2 parts Whiteblend + 1 part Cadmium Red Light + touch of Cadmium Yellow Medium
Deep Violet	2 parts Whiteblend + 1 part Ultramarine Blue + 1 part Dioxazine Purple + 1 part Payne's Gray
Medium Violet	2 parts Whiteblend + 1 part Deep Violet
Light Violet	1 part Medium Violet + 1 part Whiteblend
Dark Green	1 part Hooker's Green Deep + 1 part Burnt Umber + 1 part Burnt Sienna
Turquoise	2 part Cerulean Blue + 1 part Vivid Lime Green + 1 part Whiteblend
Deep Blue Violet	2 parts Turquoise + 2 parts Whiteblend + 1 part Ultramarine Blue + 1 part Dioxazine Purple
Light Cerulean	15 parts Whiteblend + 1 part Cerulean Blue
Pastel Pink	1 part Whiteblend + a touch of Cadmium Red Medium
Medium Ochre	3 parts Whiteblend + 1 part Yellow Ochre
Medium Yellow Green	5 parts Whiteblend + 3 parts Yellow Ochre + 1 part Hooker's Green Deep
Bright Yellow Green	5 parts Whiteblend + 3 parts Yellow Ochre + 1 part Vivid Lime Green
Off White	20 parts Whiteblend + 1 part Medium Ochre

1 Prepare the Canvas, and Paint the Sky

Trace the pattern onto the canvas with charcoal graphite paper and a stylus. Make design protectors for the geese, and place these on their images. Apply Peach in the upper left corner of the sky with the no. 6 bristle flat. Overlap various values of Sky Blue into the outer areas of the Peach. Continue adding Sky Blue across the top of the sky with the no. 12 bristle flat. Add Whiteblend incrementally to the uncleaned no. 12 bristle flat, and continue into the lower portion of the sky, making the value progressively lighter toward the horizon. Create a blustery appearance by slightly blending the sky with the ½-inch (12mm) mop. Add a touch of Light Violet to the uncleaned no. 6 bristle flat, and stipple the distant trees at the base of the sky. Double load Peach to the top of the uncleaned no. 6 bristle flat, and lightly stipple highlights on the top-left sides of some Light Violet treetops. Stipple Light Gray Green trees in front of the distant violet trees with the uncleaned brush. Brush mix Medium Ochre and a touch of Whiteblend to the top of the no. 6 bristle flat, and stipple highlights on the top-left sides of the shorter trees. Reload the brush frequently.

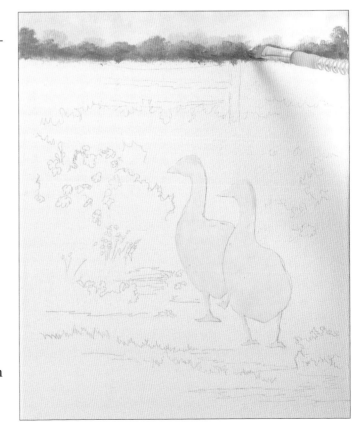

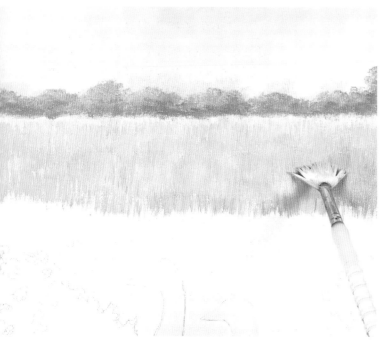

2 Add the Distant Field

Without cleaning the no. 2 bristle fan between colors, block in the distant field of grass using various values of Medium Ochre lightened with Whiteblend. Occasionally accent Medium Ochre by adding streaks of Medium Yellow Green. To create a continuous flow in the grass, start at the bottom of the tree line, and make short downward strokes, alternating the values and colors as you proceed across the canvas. As you move down, overlap the bottom portion of the previous grass strokes with the tops of the subsequent grass strokes. Reload your brush frequently, adding a touch of water to your brush each time you reload so the paint glides easily onto the canvas. Should the colors appear too splotchy or in defined rows, stroke contrasting colors over the area to create a more gradual transition.

3 Block in the Foreground Foliage

Stipple the tops of the foreground foliage with the no. 12 bristle flat and Dark Green. Frequently reload the brush, adding a touch of water each time. Scumble, tap and scrub the remaining Dark Green foliage in the foreground for texture. Anchor the foliage to the dirt area in the barnyard, and create shadows with back-and forth horizontal strokes with the ½-inch (12mm) synthetic comb moistened with Clearblend. Apply Burnt Umber at the edge of the foliage and shadows with the no. 6 bristle flat, to create the dirt, using short, choppy, horizontal strokes. Add sporadic streaks of Dioxazine Purple and Payne's Gray throughout this area with the same brush. Paint the sunlit area with the uncleaned ½-inch (12mm) synthetic comb and various values of Raw Sienna and Whiteblend. Overlap this into the wet shadow paint to create a gradual transition between values as you proceed. Apply streaks of earth and grass alternately by crunching grassy patches with the no. 2 bristle fan and Dark Green. Stroke the bottom of each area of grass with the uncleaned ½-inch (12mm) synthetic comb and some of the dirt colors. End with the darker colors in the foreground of the barnyard. Dry. Realign the pattern, and the trace the fence and flowers onto the canvas. Use charcoal graphite in the light areas, such as the fence and sunflowers, and use the white graphite in the dark areas, such as the flowers and foliage in the dark green areas.

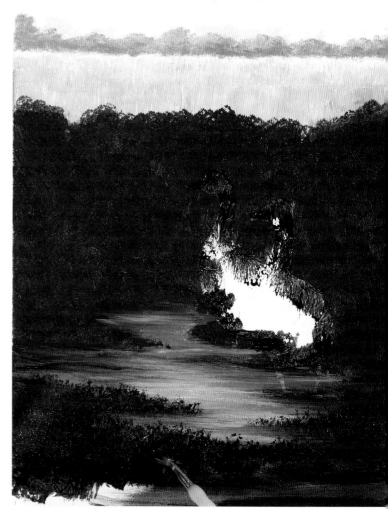

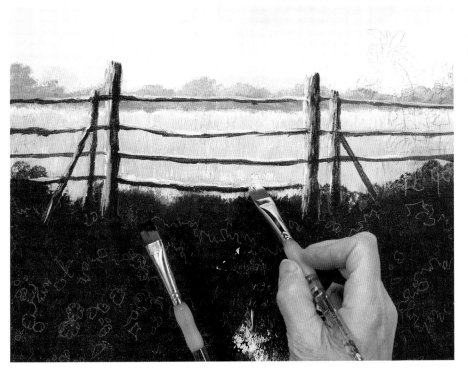

4 Paint the Fence

Paint the right side of the fence posts and the bottom side of the rails Burnt Umber, adding an occasional dash of Payne's Gray, with the ½-inch (12mm) synthetic angle. Use choppy strokes, and turn the brush vertically for the posts and horizontally for the rails. In the same manner, apply highlights to the left sides of the posts and the top sides of the rails with the ½-inch (12mm) synthetic comb using variegated values of Peach, Medium Ochre and White-blend. Blend the colors together in the center to create a rounded appearance. Dry.

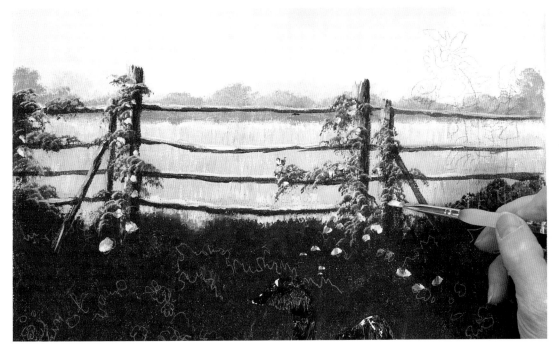

5 Add the Morning Glory Vines and Blooms

With the no. 2 bristle filbert loaded with Dark Green, lightly tap in morning glory vines along the fence post and over the rails. Reload your brush frequently. Double load the top of the uncleaned brush with Bright Yellow Green. Tap highlighted leaves on the top and left sides of the morning glory vines, reloading your brush frequently. Dry. Add morning glory blooms on the vines with the no. 4 synthetic flat loaded with a marbleized mixture of Ultramarine Blue and Whiteblend. Create various values and shapes of flowers, ranging from deep blue to almost pure white.

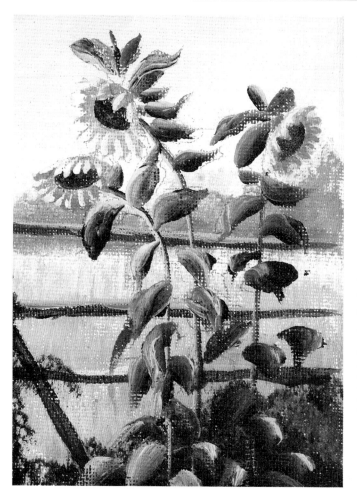

6 Paint the Sunflowers

Draw the stems of the sunflowers with a double-loaded no. 0 synthetic liner, using Dark Green and Medium Yellow Green. Add leaves on and around the stems, using the same colors double loaded onto the no. 2 synthetic round. Occasionally add Bright Yellow Green to the top of the brush for variety. Press, pull and lift your strokes to create each leaf. Pull and lift the brush to a point for the tip of each leaf. Turn the brush different directions, making various sizes, colors and shapes of sunflower leaves. Paint sunflower petals with a clean no. 2 synthetic round and a brush mixture of Yellow Ochre with a touch of Medium Ochre. Wipe the excess paint from the brush, and tap in the sunflowers' stamens with Burnt Umber thinned with water. Highlight the sunflower petals with the no. 0 synthetic liner and a very pastel brush mixture of Cadmium Yellow Medium and Whiteblend. Do not paint over the entire deep Yellow Ochre mixture. Dry thoroughly. Erase any remaining graphite lines with a kneaded eraser.

7 Add the Foreground Flowers

Add stems in the foremost flower bushes with the no. 0 synthetic liner and a watery Bright Yellow Green, stroking from the root area up and blotting the wet stems at their bases. Add a few leaves on and around the stems with the same mixture and the uncleaned no. 0 synthetic liner. Double load the no. 4 synthetic flat with a marbleized Medium Violet on the bottom and Whiteblend on the top. Tap a few violet flowers on some of the stems to the left of the geese. Double load the clean no. 4 synthetic flat with Yellow Ochre on the bottom and Cadmium Yellow Medium and Whiteblend on the top. Add slightly larger blooms on the stems in front of the violet flowers. Yellow and violet are complementary colors, so placing these flowers next to each other makes them stand out.

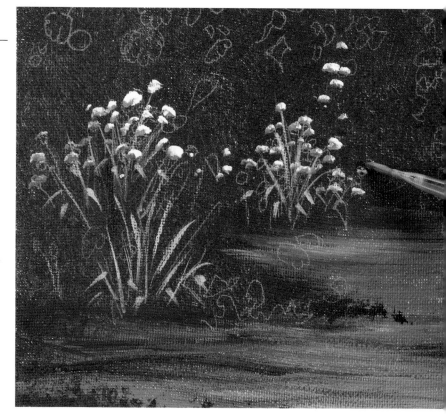

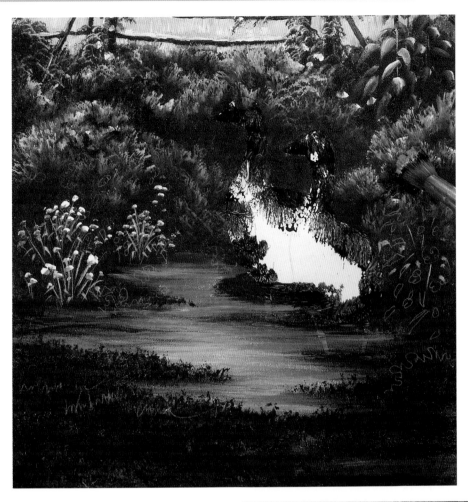

8 Add the Grass Highlight and Reflected Light

Double load Dark Green on the bottom and Turquoise on the top of the no. 2 bristle fan, and crunch reflected light in the foreground grasses. Add Deep Blue Violet to the Turquoise side of the uncleaned fan, and crunch reflected light in the foremost grass. Brush mix Medium Yellow Green and Medium Ochre to the top side of the brush, and sparingly crunch a few highlights in the grass.

9 Add the Foliage Highlight and Reflected Light

Crunch and tap Turquoise-reflected light to the right sides of the flower bushes, and randomly in the foliage with the no. 12 bristle round double loaded with Dark Green on the bottom and Turquoise on the top. Use the uncleaned brush to crunch and tap highlights on the left sides of the flower bushes by brush mixing various values of Medium Yellow Green onto the Turquoise side of the uncleaned brush. Vary the Medium Yellow Green occasionally by adding Medium Ochre. Apply less highlight in the central area of the flower bushes, concentrating the highlight on the outer left sides.

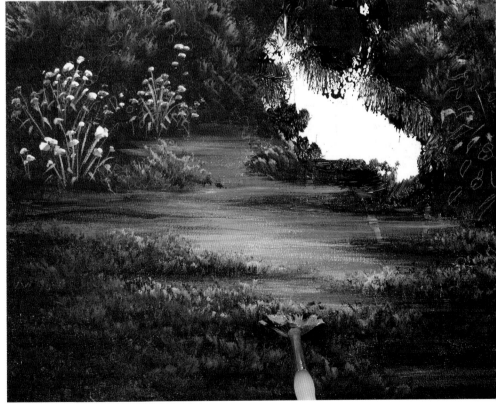

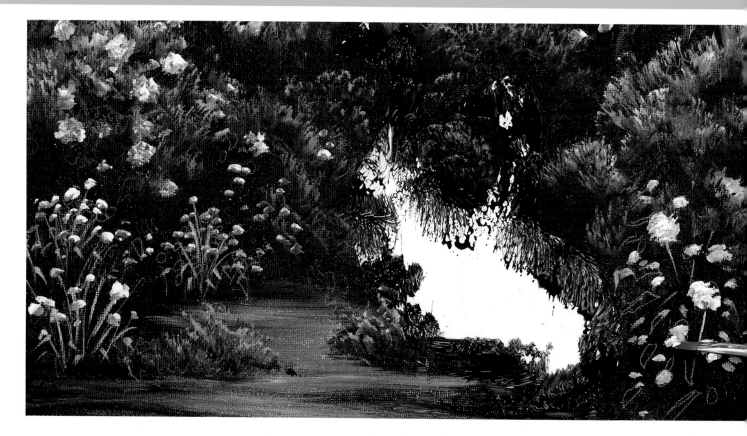

10 *Add the Peony Blooms*

Tap various sizes and shapes of peony blooms on the flower bush to the left of the geese, using the no. 2 bristle flat and a marbleized mixture of Cadimum Red Medium and Whiteblend, ranging from almost pure red on the bottom to almost pure white on the top. Brush mix Peach and Whiteblend into the uncleaned brush, then add Whiteblend to the top. Add this to the foremost peony blooms on the right side of the geese. Lightly dabble touch-ups and additional highlights with the corner of the no. 4 synthetic flat to create contrasting values of each flower's color.

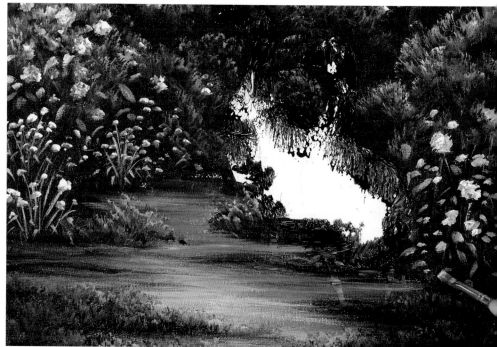

11 *Add the Peony Leaves*

Using any or all of the highlight and reflected light colors previously used in the foliage, add various shapes and sizes of peony leaves. Alternate between the colors, double loading the no. 2 synthetic round, the no. 4 synthetic flat and the no. 0 synthetic liner to create several sizes and shapes of leaves.

12 Add Detail to the Ground

Work wet-into-wet to add and blend the dirt's highlight and reflected light. Moisten the areas with a clean no. 2 bristle fan loaded with Clearblend. Apply then blend the highlight and reflected light colors into the wet Clearblend. Brush mix Whiteblend and a speck of Cadmium Yellow Medium and apply this highlight with short, choppy strokes of the ½-inch (12mm) wisp, using only the chisel edge. Blend the outside edges toward the shadows with the ½-inch (12mm) synthetic comb moistened with Clearblend. With a clean ½-inch (12mm) wisp, add streaks of Medium Violet-reflected light in some shadowy areas of the exposed earth. Soften the edges of reflected light, moving the outer edges toward the sunlit areas with the ½-inch (12mm) synthetic comb moistened with Clearblend.

13 Paint the Geese's Eyes and Beaks

Remove the design protectors from the geese. Paint the beaks Cadmium Red Light, alternating between the no. 0 synthetic liner and the no. 2 synthetic round. While this is wet, highlight the beaks' tops and edges with Medium Ochre. Paint the nostrils then add a thin line separating the top and bottom beaks with the no. 0 synthetic liner and a thin mixture of Cadmium Red Light and a touch of Payne's Gray. Paint the left side of the eye Burnt Umber and the right side Payne's Gray. Dry the eyes, then add a catchlight of Whiteblend to each eye, positioned at about 1 o'clock.

Removing Design Protectors

Once you have removed the design protectors, remove any seepage while the paint is wet with a moist cotton swab. If paint has dried under the design protectors, loosen it with the tip of your palette knife, remove what loosens then touch up any ragged edges with the appropriate colors (in this case, Whiteblend or the Dark Green).

14 Paint and Highlight the Feet and Legs

Use the no. 0 synthetic liner to paint the feet and legs with Raw Sienna, shadowed with Burnt Umber. Add dashes of Cadmium Red Light randomly on the feet and legs for a midtone, and highlight the left sides of the legs and the tops of the feet with values of Yellow Ochre and Whiteblend. Dry.

15 Add Reflected Light to the Legs

Add dashes of Light Cerulean-reflected light here and there on the right sides of the legs with the no. 0 synthetic liner.

16 Add Shadows to the Feathers

Create the contour and curvature of the geese's musculature with a gradual transition of values, ranging from Deep Violet to almost pure white with the ½-inch (12mm) wisp. Stroke back and forth with the different values, creating a gradual transition of colors, always making each stroke in the direction of the feathers' growth. Reload the brush frequently, adding more Whiteblend as you move from the darker edge of the shadow up. Add the deepest shadows on their rear ends with the no. 2 synthetic flat using Deep Violet. Paint the remaining shadows with the ½-inch (12mm) wisp, using just the tips. Apply streaks of Medium Violet to indicate reflected light on their sit-upons. Add a few streaks of Sky Blue-and Light Cerulean-reflected light where the geese merge into the sunlit areas.

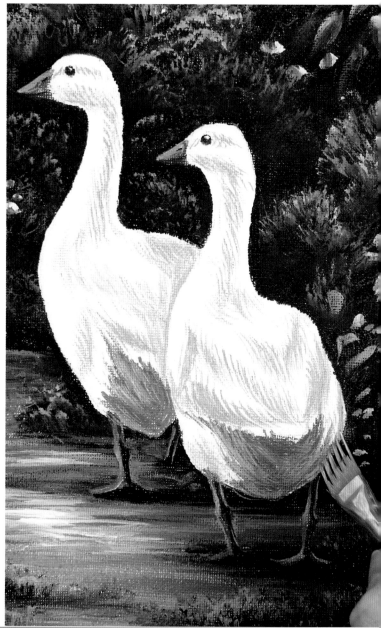

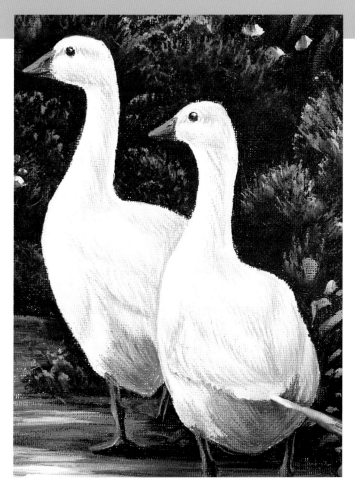

17 Add Sunlit Feathers

Add warmth to the white feathers in the most sunlit portions of the geese, use a clean ½-inch (12mm) wisp with Off White. Let your strokes follow the feathers' length and shape of the body in each area. Blot the paint occasionally with your fingers if you apply too much or overlap into the shadows. Tidy up and define areas, such as their tail feathers, cheeks and around their eyes, using the no. 0 synthetic liner and Off White, or any of the appropriate colors.

18 Add Reflected Light and Accent Colors

Using the no. 0 synthetic liner, add Pastel Pink accents on the feathers that receive medium light. With a clean no. 0 synthetic liner, add Light Cerulean-reflected light to the right of the Pastel Pink accents, overlapping into the shadows on the geese's backs, and backs of their necks. Blot to subdue these colors if they are too bold.

19 Refine the Eyes

With a thinned brush mixture of Deep Violet and Burnt Umber on a clean no. 0 synthetic liner, strengthen the shadows on the sides of the eyes with a series of parenthesis-shaped lines. Blot these shadow markings while they are wet to make them recede. Dry. Using Clearblend to work wet-into-wet, rework any area that needs it. Sign your painting. When it is thoroughly dry, spray it with an aerosol acrylic painting varnish, so you enjoy double the pleasure from your "Double Trouble" in perpetuity!

Day of Rest

Day of Rest
Acrylic on primed, stretched canvas
16" × 20" (41cm × 51cm)

The morning's peaceful quietness settles over this country village as the sounds of their little church's bells herald a "Day of Rest" from the busy world outside. It is nice to step back from our hustle-bustle world of today to a more restful time, even if it is only in our minds. May you embrace the ambiance of this graceful setting with every stroke of your brush.

Materials

Acrylic Colors
Acra Magenta, Burnt Sienna, Burnt Umber, Cadmium Red Light, Cadmium Red Medium, Cerulean Blue, Dioxazine Purple, Hooker's Green Deep, Payne's Gray, Raw Sienna, Ultramarine Blue, Vivid Lime Green, Yellow Ochre

Mediums
Clearblend, Slowblend, Whiteblend

Brushes
Nos. 6 and 12 bristle flat, no. 4 synthetic flat, no. 0 synthetic liner, no. 2 bristle fan, no. 10 bristle angle, ½-inch (12mm) synthetic angle, ½-inch (12mm) synthetic comb, ¾-inch (19mm) mop, natural sea sponge, palette knife

Pattern
Enlarge the pattern (page 108) 175 percent

Other
16" x 20" (41cm x 51cm) canvas, ½ tsp. of Slowblend per cup of water, adhesive-backed paper, aerosol acrylic painting varnish, charcoal graphite paper, little plastic cups (for the mediums and glaze), scissors, stylus

Color Mixtures

Before you begin, prepare these color mixtures on your palette:

Color	Mixture
Sky Blue	5 parts Whiteblend + 1 part Ultramarine Blue
Pastel Violet Gray	20 parts Whiteblend + 1 part Dioxazine Purple + 1 part Payne's Gray + 1 part Ultramarine Blue
Terra Cotta	3 parts Whiteblend + 1 part Burnt Sienna + 1 part Cadmium Red Light + 1 part Yellow Ochre
Light Terra Cotta	2 parts Terra Cotta + 1 part Whiteblend
Deep Terra Cotta	6 parts Terra Cotta + a speck each of Dioxazine Purple and Burnt Sienna
Dark Gray	3 parts Payne's Gray + 1 part Burnt Sienna + 1 part Whiteblend
Variegated Light Yellow	4 parts Whiteblend + 1 part Yellow Ochre
Variegated Taupe	10 parts Whiteblend + 5 parts Payne's Gray + 1 part Cadmium Red Medium
Light Payne's Gray	1 part Whiteblend + 1 part Payne's Gray
Warm Brown	1 part Burnt Sienna + 1 part Payne's Gray + 1 part Whiteblend
Dark Green	3 parts Hooker's Green Deep + 3 parts Burnt Sienna + 3 parts Burnt Umber + 1 part Whiteblend (vary the all components to get light, medium and dark)
Medium Gray Green	10 parts Dark Green + 1 part Whiteblend
Light Gray Green	4 parts Whiteblend + 1 part Dark Green
Dusty Teal	1 part Ultramarine Blue + 1 part Cerulean Blue + 1 part Vivid Lime Green + 1 part Hooker's Green Deep + 1 part Whiteblend
Variegated Yellow Green	1 part Yellow Ochre + 1 part Whiteblend + a touch of Vivid Lime Green
Misty Glaze	2 parts water + 2 parts Cerulean Blue + 1 part light Sky Blue

1 Prepare the Canvas and Paint the Sky

Trace the pattern onto the canvas. Make design protectors (page 8) for the buildings, and place them over the tracing. Brush mix, apply, then blend the sky and clouds a small section at a time. With the no. 12 bristle flat, brush mix various values of Sky Blue, using Ultramarine Blue and Whiteblend. Apply these variegated blues in the top of the sky. With the no. 10 bristle angle, immediately add cloud formations with Whiteblend overlapping the bottom into the Sky Blue. Blend slightly with the ¾-inch (19mm) mop. Repeat these steps of applying the blue, then white, then blending until you have clouds across the entire sky. Remember, no two cloud shapes are alike.

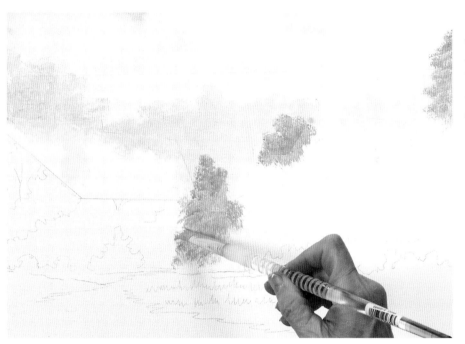

2 *Add the Distant Trees*

Add a touch of Pastel Violet Gray to the uncleaned no. 12 bristle flat, and stipple the distant background trees. Add a touch more Whiteblend to the brush for the trees tucked behind the buildings. Use the no. 6 bristle flat with Light Gray Green to stipple the trees behind the church and house. Double load Yellow Ochre and Whiteblend to the top side of the uncleaned brush, and tap highlight the top-left sides of these trees.

3 *Paint the Church*

Remove the design protectors. Paint and blend one roof section at a time, following light and dark patterns. Alternate between the no. 0 synthetic liner in tight places and the no. 4 synthetic flat in larger areas as you paint. Use Terra Cotta and Deep Terra Cotta for deeper values and Light Terra Cotta for lighter values. Paint the sunlit side of the belfry, the steeple's base and the church with Variegated Light Yellow. Apply, and leave mottled. Paint the shadow side of the belfry and its base with a brush mixture of Raw Sienna and White-blend tinted with a touch of Burnt Sienna. Paint the shadow under the steeple roof with the no. 0 synthetic liner and Dark Gray. Soften the bottom of these shadows with the no. 4 synthetic flat.

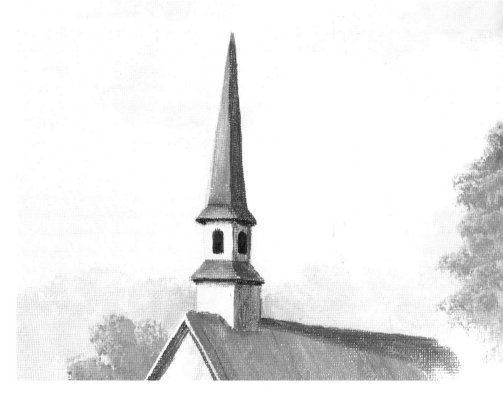

Paint the windows in the belfry with Deep Terra Cotta. Paint the vestibule roof Variegated Taupe with the ½-inch (12mm) synthetic angle. Vary the value by adding random touches of Whiteblend. Make each brushstroke conform to the roof's slant. Darken the Variegated Taupe with a touch more Payne's Gray and Dioxazine Purple. Add the shadow cast by the steeple, and blend. With the no. 0 synthetic liner and this color, paint the shadow under the vestibule's eaves.

4 *Paint the Houses*

Make all the brushstrokes on the roofs and eaves conform to each roof's slant. Paint the roof farthest to the left and the eave on the center house using the ½-inch (12mm) synthetic angle and Payne's Gray and a touch of Whiteblend. Use a darker value of this for the gable of the far left house. Add Payne's Gray and streak it with a brush mixture of Whiteblend and Variegated Light Yellow on the ½-inch (12mm) synthetic comb. Paint the roof of the house next to the church with a clean ½-inch (12mm) synthetic angle and different values of Sky Blue. Add a touch of Payne's Gray to the mixture and add the eave's shadows. Paint the roof of the center house Warm Brown with the ½-inch (12mm) synthetic angle, darkening the paint with Payne's Gray for the shadows. Use the no. 0 synthetic liner and the steeple's roof colors to paint all the chimneys. Highlight the leading edge of the roofs with the no. 0 synthetic liner and a brush mixture of Whiteblend and Variegated Light Yellow. Dry.

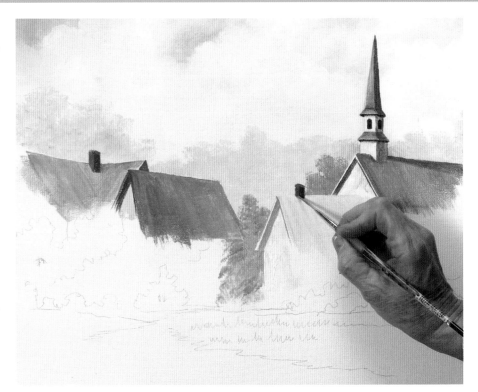

5 *Add the Foreground Trees*

Stipple the Light Gray Green trees in the middle ground with the no. 6 bristle flat. Double load Yellow Ochre and Whiteblend to the top of the uncleaned brush, and highlight the top-left sides of these trees. Add Medium Gray Green to the uncleaned brush and stipple

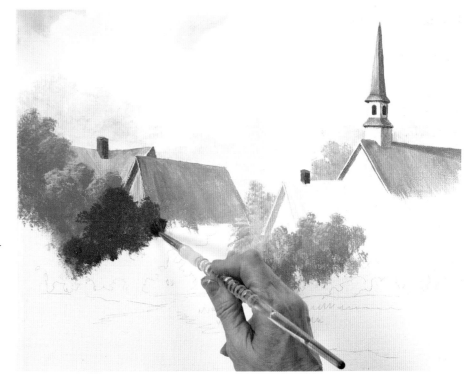

the darker foremost trees on the left side of the canvas, extending them down to the crest of the meadow. Reload the brush frequently, controlling the value of the Dark Green by adding Whiteblend to the mixture as you progress. Make sure none of these trees are pure Dark Green and the colors are variegated.

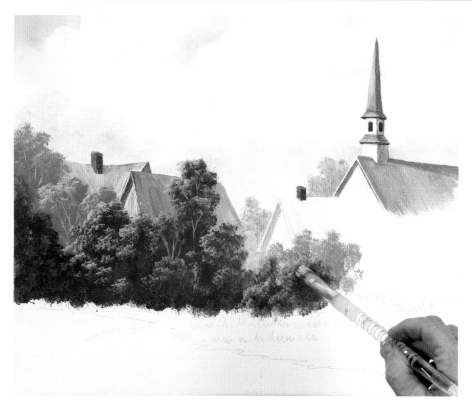

6 Detail the Foremost Middle Trees

Double load Dusty Teal to the top side of your uncleaned no. 6 bristle flat, and tap reflected light into the right sides of the darker foliage. Create Variegated Yellow Green highlights for these trees by double loading the Dusty Teal side of the brush with a brush mixture of Yellow Ochre, Whiteblend and a touch of Vivid Lime Green. Stipple the highlights on the top-left sides of the trees. Double load the no. 0 synthetic liner with Warm Brown, for the shadow side of the twigs, and Raw Sienna and Whiteblend for the highlight. Draw tree trunks and twigs in some of the shadowy areas of the distant trees. Dry.

7 Add a Morning Mist

Create the Misty Glaze, and test it before you continue. It should be translucent. If it is too opaque, add more Clearblend and water before continuing. Apply the Misty Glaze over the distant left house and the most distant trees in front of it with the no. 12 bristle flat. Soften the edges with the ¾-inch (19mm) mop. There shouldn't be any abrupt endings. Repeat to create a drifting mist coming down the trail between the two center houses. Use this misting technique to subdue the Pastel Violet Gray trees or any of the distant houses or trees, should they appear too bold. To partially subdue foliage, apply the glaze. Then tap over the wet glaze with a clean, moist natural sea sponge, and blend, leaving a mottled but more translucent mist.

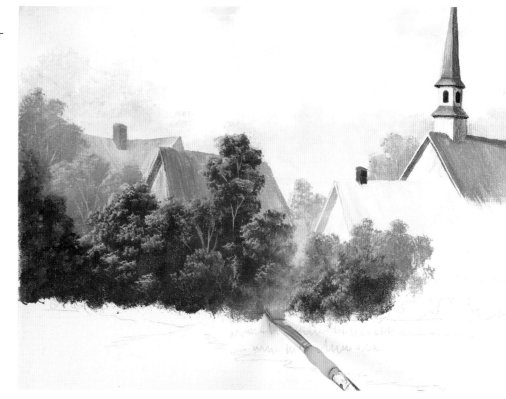

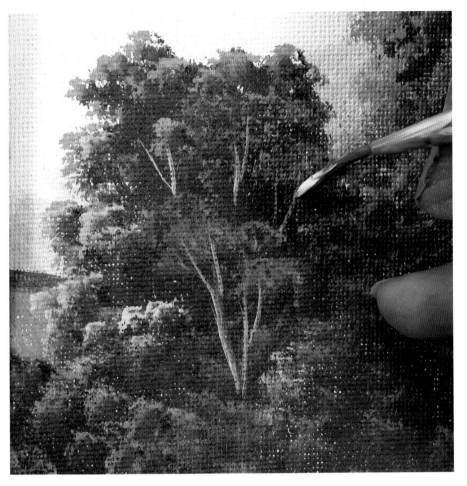

8 Add the Foremost Trees on the Right Side

Stipple the foremost trees on the right, using the same techniques, colors and brushes you used for the trees on the left, brush mixing and adding the same reflected light and highlights as well. Double load your no. 0 synthetic liner with Warm Brown for the shadow and Raw Sienna with Whiteblend for the highlight. Position the brush so the highlight is on the left side, and draw tree trunks and twigs in the shadowy areas of a few trees.

9 Block in the Grass and Trail

Using the uncleaned no. 6 bristle flat, add a touch more Dark Green to the Medium Gray Green tree, and stipple darker, low-lying shrub foliage at the base of the trees. Scumble this horizontally over the grassy areas, ending with larger Dark Green shrub foliage in the foreground. As you proceed, soften the edges of the wet grass next to the trail with the ½-inch (12mm) synthetic comb moistened with Clearblend. Apply this with horizontal strokes. Paint the path using a brush mixture of Burnt Umber, Burnt Sienna and a touch of Whiteblend, darkening the values gradually by adding more Burnt Umber, Dioxazine Purple and the occasional touch of Payne's Gray as you proceed to the path's foreground. Begin with short strokes in the distance, and progressively increase the strokes' length and the darkness as you move forward.

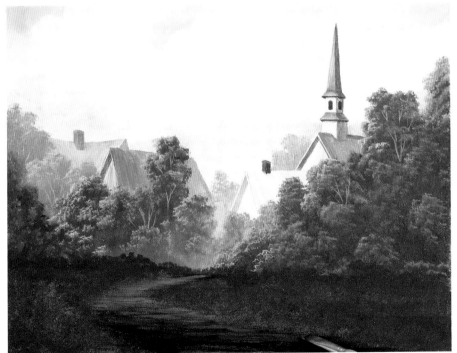

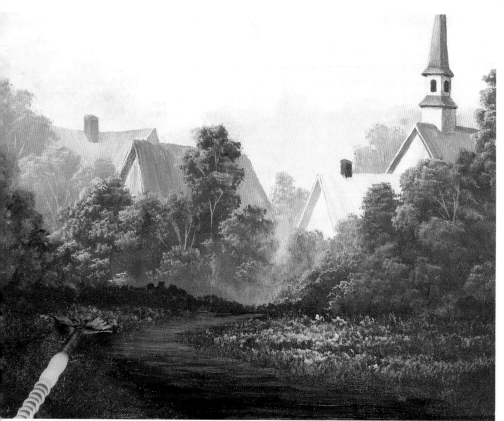

10 Highlight the Grass

Double load a no. 2 bristle fan with Medium Gray-Green on the bottom and brush-mixed Variegated Yellow Green on the top. For the grass highlights, position the fan's bristles horizontally on the canvas, and holding the handle perpendicular to the canvas, crunch softly. Move the brush horizontally around in the grass with each crunch. Reload frequently to retain a sharp appearance. When you're done highlighting the sunlit grass, wipe the excess Variegated Yellow Green from the top of the brush, and add the Dusty Teal along with more Medium Gray Green in its place. Use the same technique to apply this in the shadows.

11 Add Middle and Background Flowers

For the flowers, brush mix a variety of variegated dull peach, pink and yellow marbleized mixtures. With the no. 4 synthetic flat, begin with Acra Magenta, mixed with Pastel Violet Gray, for the rose-colored flowers, adding a touch of Dioxazine Purple to the mix for the deeper blooms. Dab the flowers with only one corner of the brush. For the peachy-pink blooms, add Yellow Ochre and Whiteblend to the mixture. For the distant flowers, add more Yellow Ochre and Pastel Violet Gray.

12 Add Foreground Flowers

Using the no. 4 synthetic flat and more paint, apply larger, brighter and more widely spaced flowers in the foreground shrubs. Using variegated values of Cadmium Red Medium, Yellow Ochre, Pastel Violet Gray and Whiteblend for the peachy-pink flowers on the left. Add more Yellow Ochre and Whiteblend to the peachy-pink for peachy-yellow flowers on the right.

13 Add the Foremost Flower's Leaves and Stems

Add a few detailed leaves and stems with the no. 0 synthetic liner, using any of the greens previously used.

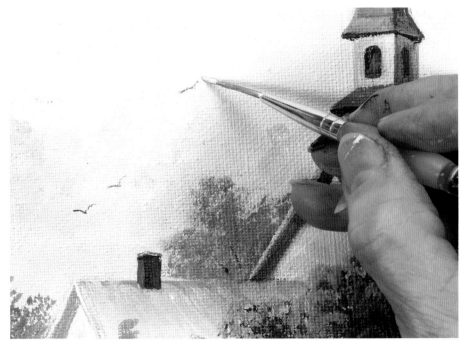

14 Add Birds

Paint the birds flying in with the no. 0 synthetic liner using Light Payne's Gray thinned with water. Sign and dry your painting. Spray it with an aerosol acrylic painting varnish. Sit back, and enjoy your "Day of Rest."

All in a Day's Work

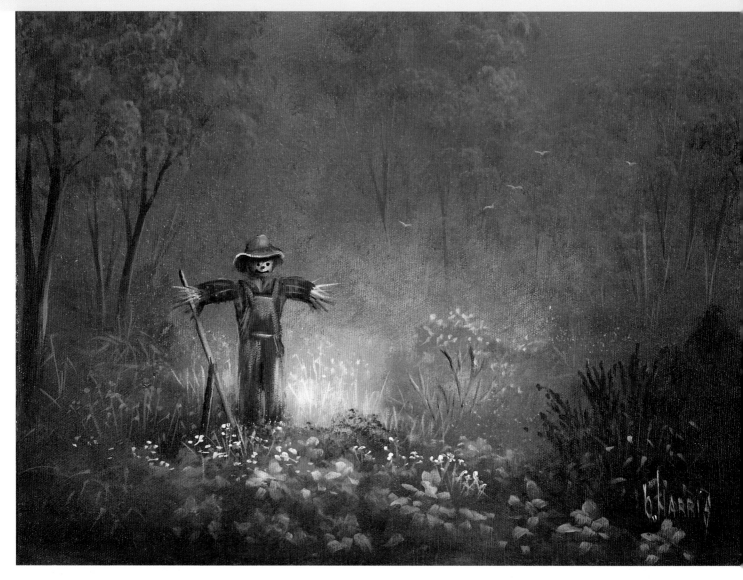

Scarecrows bring out the kid in us even when we know he's doing a difficult job. This garden "caretaker" puts our fears to rest, come rain or shine, day or night. As night falls, we scurry into the comfort of home to feast on the bounty of his labor as he stands like a sentinel, courageously embracing the unknown, confronting the menaces that threaten our harvest. For him, it is "all in a day's work."

The instructions in this book are your "scarecrow." Think of this and all other art-instruction books as the "caretakers" of timeless painting techniques, saving them for you until you reap your harvest. For an art teacher and author, day or night, rain or shine, it is a joy to record, stand guard over, and make the "harvesting of painting instructions" available to all who hunger. It is "all in a day's work."

All in a Day's Work
Acrylic on primed, stretched canvas
12" × 16" (30cm × 41cm)

Materials

Acrylic Colors
Acra Magenta, Burnt Sienna, Burnt Umber, Cadmium Red Light, Cadmium Red Medium, Cadmium Yellow Medium, Cerulean Blue, Dioxazine Purple, Hooker's Green Deep, Payne's Gray, Raw Sienna, Ultramarine Blue, Vivid Lime Green, Yellow Ochre

Mediums
Slowblend and Whiteblend

Brushes
2-inch (51mm) bristle flat, nos. 6 and 12 bristle flat, no. 4 synthetic flat, no. 2 synthetic round, no. 0 synthetic liner, ¾-inch (19mm) mop, ½-inch (12mm) synthetic angle, ½-inch (12mm) synthetic comb, natural sea sponge, palette knife

Pattern
Enlarge the pattern (page 109) 182 percent

Other
12" × 16" (30cm × 41cm) canvas, ½ tsp. of Slowblend per cup of water, aerosol acrylic painting varnish, charcoal and white graphite paper, little plastic cups (for the mediums), stylus

Color Mixtures

Before you begin, prepare these color mixtures on your palette:

Plum	1 part Dioxazine Purple + 1 part Burnt Sienna + 1 part Burnt Umber + 1 part Whiteblend
Taupe	1 part Plum + 1 part Burnt Umber + 1 part Payne's Gray
Wheat	2 parts Cadmium Yellow Medium + 1 part Burnt Sienna + 1 part Whiteblend
Dark Brown Green	2 parts Burnt Umber + 1 part Hooker's Green Deep
Medium Brown Green	2 parts Dark Brown Green + 1 part Whiteblend
Camel	1 part Raw Sienna + 1 part Whiteblend
Off White	30 parts Whiteblend + 1 part Yellow Ochre
Dull Yellow Green	2 parts Wheat + 1 part Whiteblend double-loaded with Medium Brown Green
Light Blue	6 parts Whiteblend + 1 part Ultramarine Blue
Medium Green	1 part Hooker's Green Deep + 1 part Vivid Lime Green + various amounts of Whiteblend
Lime Green	3 parts Vivid Lime Green + 1 part Yellow Ochre + 1 part Whiteblend
Lemon Yellow Green	6 parts Whiteblend + 2 parts Vivid Lime Green + 2 parts Cadmium Yellow Medium
Teal Blue Green	1 part Cerulean Blue + 1 part Vivid Lime Green + 1 part Whiteblend
Violet	10 parts Whiteblend + 1 part Dioxazine Purple
Fuchsia	10 parts Whiteblend + 1 part Acra Magenta
Navy	1 part Payne's Gray + 1 part Ultramarine Blue

1 Block in the Background and Foreground

Load your 2-inch (51mm) bristle flat with a generous amount of Plum. Basecoat the top two-thirds of the canvas, scrubbing the paint down into its pores. Basecoat the bottom third of the canvas with a generous amount of Dark Brown Green, using the no. 12 bristle flat. Overlap where the colors join.

2 Connect the Background and Foreground

Wipe the excess Dark Brown Green from the no. 12 bristle flat, and use it to stipple where the Plum and Dark Brown Green overlap, blending the colors. Create the illusion of foliage by overlapping the background. With your uncleaned no. 12 bristle flat, stipple Medium Green highlights in the central area of the foreground foliage where the colors blend. Dry.

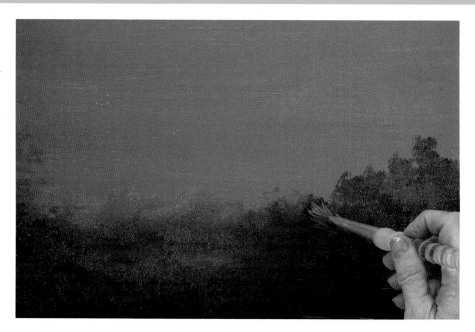

3 Add Illuminated Area

With a clean no. 12 bristle flat, generously apply Wheat in the center of the canvas, scrubbing to connect to the Dark Brown Green and Medium Green foreground area at the bottom. As you move upward, reload the no. 12 bristle flat with a touch of Burnt Sienna. As you continue upward, add Plum to the uncleaned brush, creating a gradual transition in the colors until you match with the Plum background. Blend with the ¾-inch (19mm) mop. Dry. Transfer the pattern with a stylus using the white graphite paper in the shadow areas and the charcoal graphite paper in the light areas.

4 Add the Distant Tree Trunks

Apply the middle ground and most distant tree trunks and twigs with the no. 0 synthetic liner double loaded with Camel and thinned Taupe. Hold the brush so that Camel is on the right sides of the trees, and blot each tree trunk at its base, making it fade into the background. Darken the Taupe with Burnt Umber and Payne's Gray. Paint the larger trees on the left, using the ½-inch (12mm) synthetic angle for the trunks and the no. 0 synthetic liner for the limbs. Blot their bases. Tap Camel highlights on the lower portions on the right of some of the foremost trees with the ½-inch (12mm) synthetic comb. Use the no. 6 bristle flat loaded with Medium Brown Green to randomly stipple foliage in the treetops; blot occcasionally to subdue. Dry-brush, scumble and smudge hints of Medium Brown Green over portions of the background to suggest a forest behind the trees. Add a touch of Dark Brown Green to the Medium Brown Green, and darken the foliage on the foremost left trees.

5 Highlight the Distant Tree's Foliage

Load the uncleaned no. 6 bristle flat with Medium Brown Green and double load the top side with Dull Yellow Green. Stipple highlights on the top-right sides of the leaf clusters. Stipple some Medium Brown Green in the foreground to tuck in the scarecrow's legs, overlapping leafy edges into the Wheat highlighted area. Add a touch of Vivid Lime Green to your no. 6 bristle flat for an olive green. Smudge lighter areas of foliage around the scarecrow and the illuminated area.

6 Add Glow Behind the Scarecrow

With the no. 0 synthetic liner, dab Off White in the lightest area next to the scarecrow. Scrub the edges of the Off White on either side of the scarecrow to blend, creating a glow. Use the liner to add tall grass around the area with watery thin Off White. Blot each blade at its base, then dab Off White seedpods on their tops. Add a touch more Yellow Ochre to the Off White, and add additional seedpods behind the initial layer of seedpods.

7 Paint the Scarecrow

Paint the hat with the no. 4 synthetic flat, using Burnt Umber for the shadow and Camel for the middle value. Highlight along the rim of the hat with Wheat and Off White, using the no. 0 synthetic liner. For the head, use the no. 2 synthetic round with Burnt Umber for the shadow, but use the no. 0 synthetic liner for the Camel middle values and Wheat highlights. Tap to blend, creating a round appearance. Add the mouth and eyes with the no. 0 synthetic liner, using Payne's Gray. Apply a dot of Cadmium Red Light for the nose, using Burnt Umber for its small shadow. Double load the liner using Burnt Umber for the shadow and Camel for the highlight, and draw the the scarecrow's shovel handle. Add the straw arms with the liner, using Burnt Umber and Camel for shadow and highlight, repectively. Highlight the arms with Wheat then add a few streaks of Off White for the highlights.

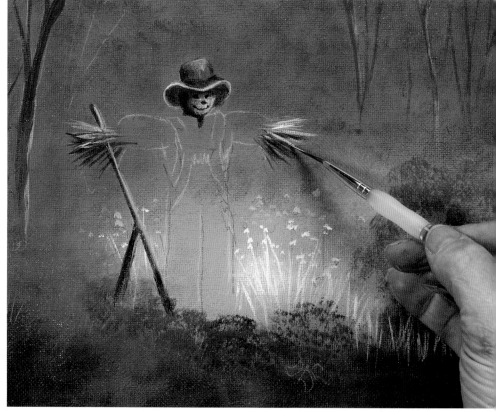

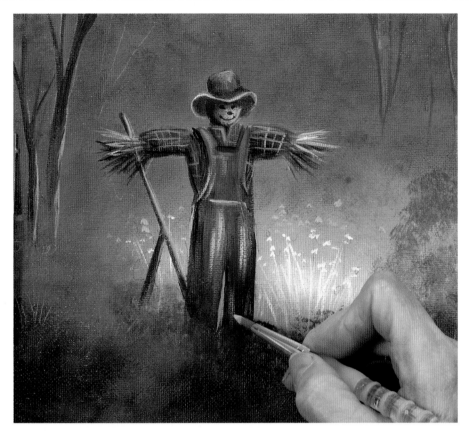

8 Add the Clothing

Paint the shirt Cadmium Red Medium thinned with water on the no. 4 synthetic flat. Add a touch of Payne's Gray to this and add the shirt's shadows. Highlight the shirt, using Cadmium Red Light and Whiteblend with the no. 0 synthetic liner. Add shadows to the shirt with a clean liner, using a mixture of Payne's Gray and Cadmium Red Medium. With the uncleaned no. 0 synthetic liner add the plaids with a mixture of Whiteblend and a touch of Payne's Gray. Paint the coveralls Navy with the no. 4 synthetic flat, adding a touch of Whiteblend to the Navy for the coverall highlights. With the no. 2 synthetic round and a slightly lighter value of Light Blue, highlight the leading edge of some folds. Add the handkerchief in the front pocket with the shirt colors and a clean no. 2 synthetic round.

9 Add the Middle Ground Shrubs

Add the shrub twigs to the right of the scarecrow with the no. 0 synthetic liner double loaded with Burnt Umber and Camel. Dab tiny leaves with Vivid Lime Green and a touch of Whiteblend on the top-right side of the shrub. Add a touch of Dark Brown Green to the uncleaned no. 0 synthetic liner, and paint a few additional leaves to the shrub's center and left side.

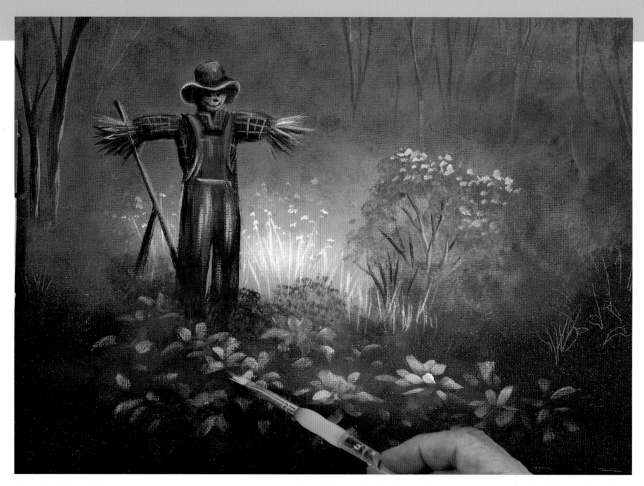

10 Add the Foreground Vegetables

With the clean no. 4 synthetic flat, add foreground plants, using various values of the Teal Blue Green mixture. Form the plants using loose, individual strokes that connect to a center. Keep the paint fluid, and use a quick stroke. Add Lime Green to the top of the uncleaned brush to paint brighter leaves of the same plants. Add Lemon Yellow Green to the top side of the same uncleaned brush for the brightest leaves. Reload frequently, adding water to your brush and mixtures as needed.

11 Add the Red Bushes

For the red bush on the right, use the ½-inch (12mm) synthetic comb to mix various red values of Cadmium Red Medium and Payne's Gray. Make choppy strokes to form the shadowed part of the bush. Fan the strokes out slightly at the bush's sides. With the clean ½-inch (12mm) synthetic comb double loaded with Cadmium Red Medium on the right and Cadmium Red Light on the left, vertically chop in blooms above the shadowy base.

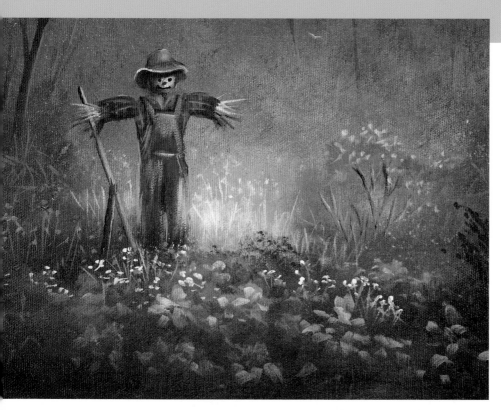

12 Add Tiny Flowers

Using watery thin values of any of the greens previously used, fill in stems and leaves between the vegetables and scarecrow with the no. 0 synthetic liner. Rinse the brush, then with the tip of the no. 0 synthetic liner double loaded with Violet on the bottom and Whiteblend on the top, add blooms on the stems. Using the same brush, add a few random light blue flowers. With a clean no. 0 synthetic liner, dabble a patch of red flowers to the right of the scarecrow. Add Fuchsia to the uncleaned brush, and dabble some flowers to his left.

13 Add Distant Flowers

Add a touch of Fuschia to a moistened natural sea sponge, and lightly tap a few specks of distant flowers in the background.

14 Add Birds

Using the no. 0 synthetic liner loaded with watery thin Camel, paint the flying birds. Sign your painting, let it dry, then spray it with aerosol acrylic painting varnish. Take it all in after a hard day's work!

Conclusion

Looking back over the years, my art has provided me lifelong memories and fun times painting with new friends all across our great land. Art has enriched and enhanced my life in ways that no amount of money can buy. I am in awe of the opportunities it has provided and doors that it continues to open. I sincerely hope your life as an artist provides you as much diversity, excitement, peace and contentment as it has me.

You, as well as I (or anyone who desires to), can learn to become an accomplished artist. After my first experience in a paint-along seminar, I discovered I had a desire to learn more. I pursued art and grew with it. I quickly realized you don't start out being an excellent artist or teacher, you develop as you go. I started teaching long before I felt adequate to do so. The marvelous thing I discovered when I started teaching is that it benefited me as much as it did the students! I discovered that sharing accelerated my artistic skills faster than taking classes. Teaching has taught me to be creative, has rapidly expanded my abilities and has brought me more joy than any previous occupation. Nothing matches the delight I receive from seeing the elation on a happy student's face as they leave my classroom with a beautiful painting that they have accomplished! So, if you are not as happy as you want to be, or as skilled as you want to be as an artist, you should find someone to teach. You will be blessed many times over. I believe it is nature's way of rewarding you for sharing.

I wish you happiness and abundant success!

Sincerely, your painting pal,
Brenda Harris

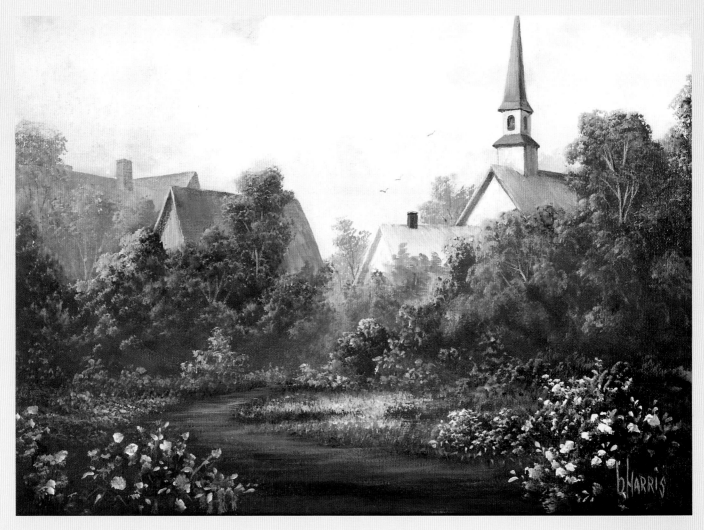

Day of Rest
Acrylic on primed, stretched canvas
16" x 20" (41cm x 51cm)

Spring Flowers
Acrylic on primed, stretched canvas
11" × 14" (28cm × 36cm)

Patterns

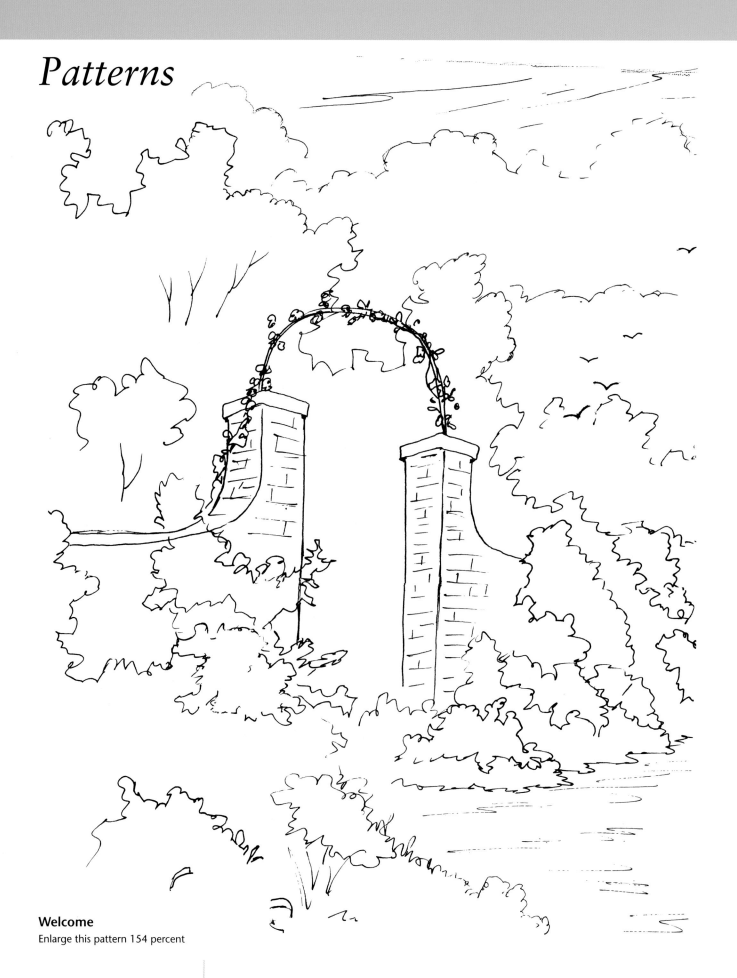

Welcome
Enlarge this pattern 154 percent

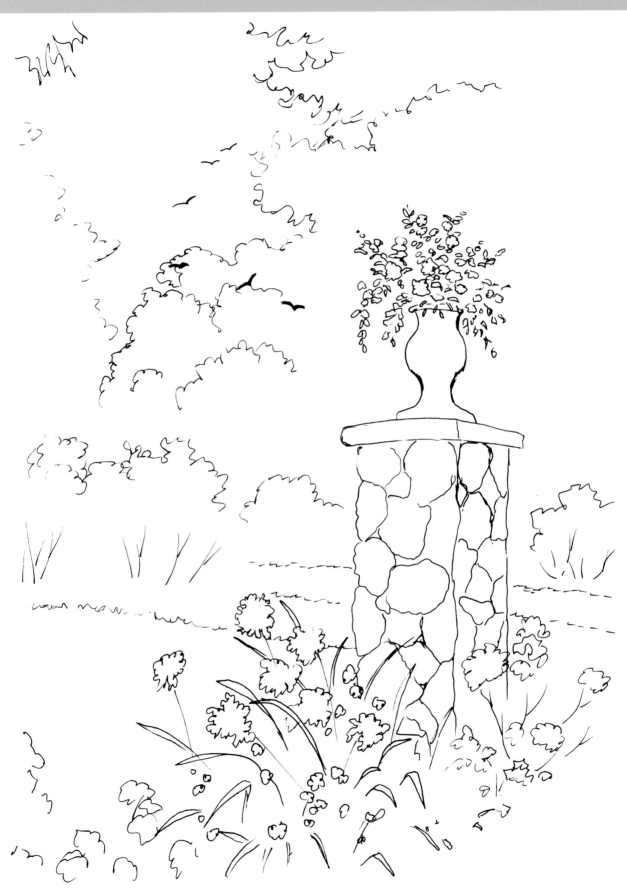

Southern Living

Enlarge this pattern 154 percent

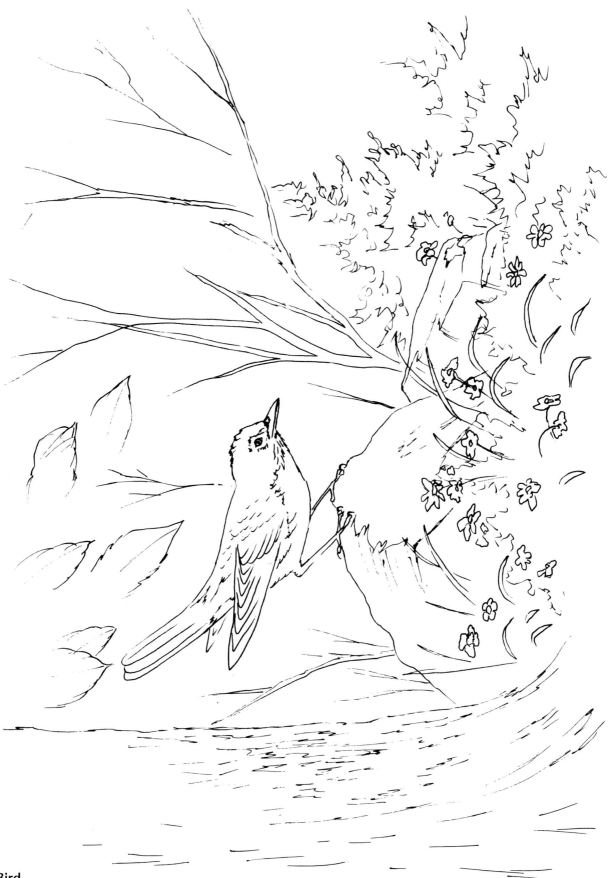

Early Bird

Enlarge this pattern 170 percent

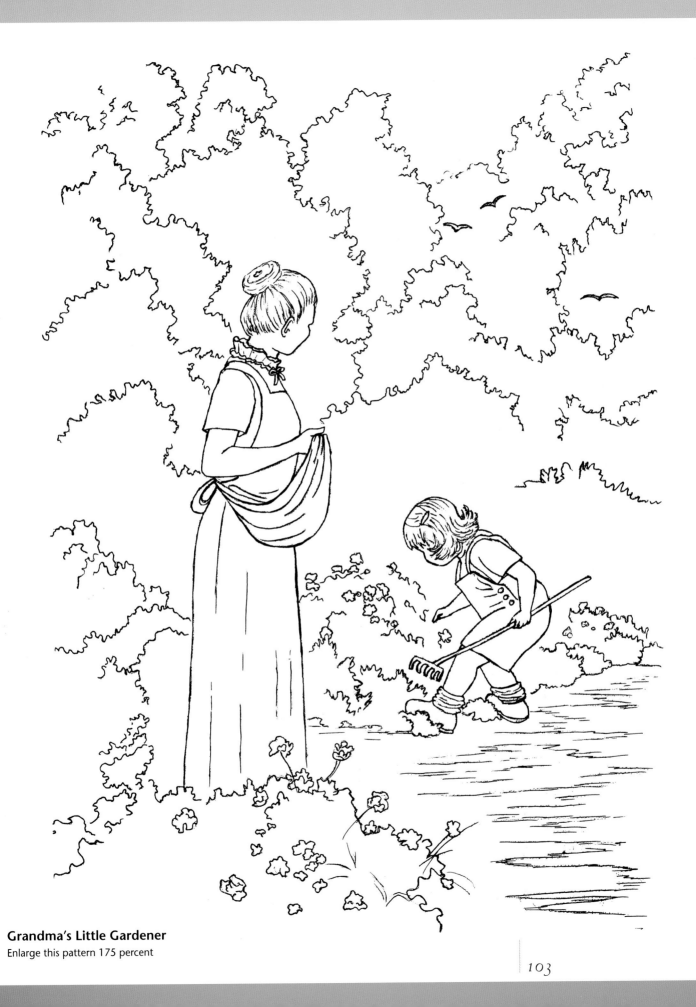

Grandma's Little Gardener
Enlarge this pattern 175 percent

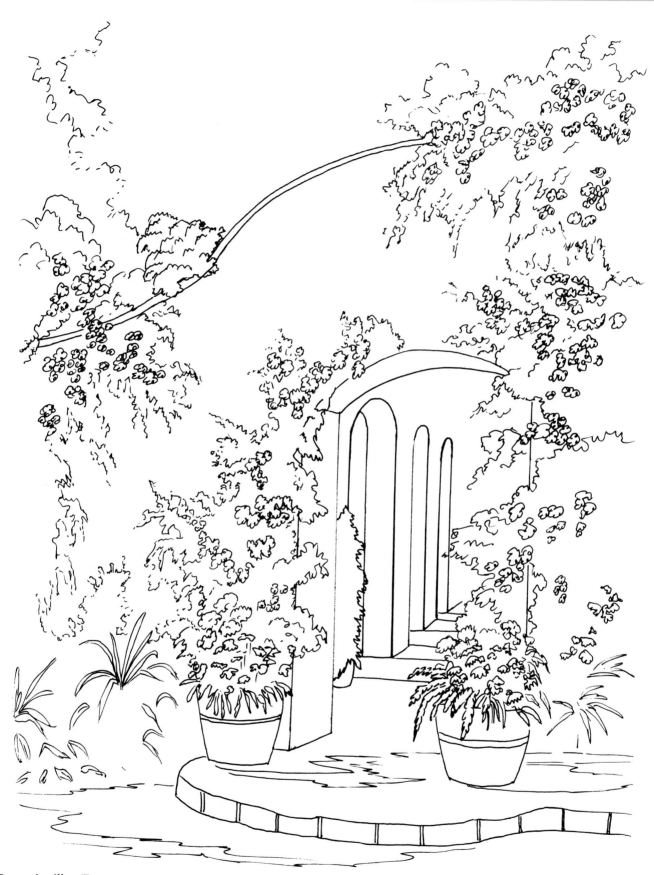

Bougainvillea Terrace
Enlarge this pattern 175 percent

Vine Ripened
Enlarge this pattern 175 percent

Spring Flowers
Enlarge this pattern 167 percent

Double Trouble
Enlarge this pattern 159 percent

Day of Rest
Enlarge this pattern 175 percent

All in a Day's Work
Enlarge this pattern 182 percent

Index

3 1143 00773 9486

Learn to paint like the pros with these other fine North Light Books!

Beloved TV painter Brenda Harris brings all the charm and approachability of her PBS show directly to you with this easy to follow instructional guide. Thirteen step-by-step projects will have you painting heartwarming scenes ranging from landscapes and barns to flowers and birds. With templates that help you easily transfer every project to your canvas, *Painting with Brenda Harris* will have you creating fast and fun acrylic scenes in no time!

ISBN-13: 978-1-58180-659-5
ISBN-10: 1-58180-659-0
Paperback, 112 pages, #33254

In the second installment of her series, well-known TV painter Brenda Harris presents 13 new fast, easy and fun acrylic projects. Brenda guides you through each *Precious Time* step by step, from the first brushstroke down to the last charming detail. With her explanations of all the basic techniques and and dozens of useful tips, as well as patterns for each project, you'll create a lovely painting you can be proud of in just a few hours!

ISBN-13: 978-1-58180-698-4
ISBN-10: 1-58180-698-1
Paperback, 112 pages, #33357

In the third installment of her series, Harris provides you with 10 easy-to-follow step-by-steps that result in beautiful acrylic paintings, instruction that requires no prior knowledge of art, and project patterns that reduce the fear of making mistakes.

ISBN-13: 978-1-58180-719-6
ISBN-10: 1-58180-719-8
Paperback, 112 pages, #33416

These books and other fine North Light titles are available at your local fine art retailer, bookstore or online supplier.